LEONARDO LIVES

corpo lunare

A

A

LEONARDO *LIVES*

The Codex Leicester and Leonardo da Vinci's
Legacy of Art and Science

Trevor Fairbrother and Chiyo Ishikawa

Seattle Art Museum
in association with
University of Washington Press
Seattle and London

This book has been published in conjunction with the exhibition *Leonardo Lives: The Codex Leicester and Leonardo da Vinci's Legacy of Art and Science,* exhibited at the Seattle Art Museum from October 23, 1997, to January 4, 1998.

The Codex Leicester has been lent by Bill and Melinda Gates.

A leadership grant has been provided by the Robert Lehman Foundation, Inc.

Major corporate sponsorship includes generous gifts from
U.S. Bank—Exhibition Sponsor
The Seattle Times—Museum Sponsor.

AT&T is the exhibition communications sponsor.
United Airlines is the exhibition transportation sponsor.
IBM is the exhibition technology sponsor.
Interpretive software and in-kind support has been provided by
Corbis Corporation.
Additional support has been provided by Bill and Melinda Gates.

All passages cited within from the Codex Leicester are from the English translation by Carlo Pedretti as given in *Leonardo da Vinci* (1996, CD-ROM) and are quoted with the kind permission of Corbis Corporation.

Cover: Codex Leicester, detail of folio 1r, with inset details from cat. nos. 2, 6, 13, 15, 17, 23, 25, 26, 30, 34, 35, 43, 44, and fig. 16, p. 33.
Back cover: Marcel Duchamp, *L.H.O.O.Q.* (detail), cat. no. 13.
Front flap: Codex Leicester, folio 7r.
Back flap: Josef Beuys, *Minneapolis Fragments,* cat. no. 5.
Frontispiece: Codex Leicester, detail of folio 2r.
Title page: Giuseppe Longhi, detail of *Vitruvian Man,* cat. no. 26, and Robert Arneson, *A Question of Measure,* cat. no. 2 (© Estate of Robert Arneson/Licensed by VAGA, New York, NY).

Library of Congress
Cataloging-in-Publication Data
Fairbrother, Trevor J.
 Leonardo lives : the Codex Leicester and Leonardo da Vinci's legacy of art and science / Trevor Fairbrother and Chiyo Ishikawa.
 p. cm.
 Catalog of an exhibition held at the Seattle Art Museum.
 Includes bibliographical references.
 ISBN 0-295-97688-8 (soft : alk. paper)
 1. Hydrodynamics—Early works to 1800—Exhibitions. 2. Hydraulics—Early works to 1800—Exhibitions. I. Ishikawa, Chiyo.
II. Leonardo, da Vinci, 1452–1519.
III. Seattle Art Museum. IV. Title.
TC171.F35 1997
627–dc21 97-30954

Printed in Hong Kong

Contents

Director's Foreword

Leonardo Lives brings to Seattle an unprecedented opportunity to witness first-hand the remarkable Codex Leicester, a product of Leonardo da Vinci's restless intellectual curiosity. By about 1508, when the Renaissance master began to work on this notebook, he had already painted his most acclaimed work, the *Mona Lisa,* and was working in Milan on the enigmatic *Virgin and Child with Saint Anne.* Both pictures feature meticulously painted landscape backgrounds that testify to Leonardo's study and scientific understanding of geology, weather, rivers, and mountains—issues that he pursued in the Codex Leicester. With this exhibition and catalogue, the Seattle Art Museum explores the close relationship of art and science in Leonardo's work. In addition, recognizing that Leonardo was one of the most influential figures of Western culture, we present the variety of ways in which he has continued to inspire artists from the sixteenth century to the present.

Given Leonardo's eminence, it is not surprising that the new technologies of ensuing eras—engravings, photographs, facsimiles, and computers—have often been applied to his work in hopes of discovering new insights or making it more accessible. An exciting part of *Leonardo Lives* is the opportunity to use a new software tool to closely examine the codex. Designed by Corbis Corporation, the Codescope allows visitors to access the sheets in several ways, including instant transcriptions into English of any given section of Leonardo's reversed handwriting.

When the Seattle Art Museum announced plans to exhibit the codex, we were delighted by the enthusiasm of many cultural and educational institutions in the region. A meeting with representatives from more than thirty institutions inspired a lively array of programming devoted to Leonardo throughout the city, including theater, music, and museum projects.

In this time of diminished resources for the arts, it is especially gratifying to acknowledge the early and generous grant from the Robert Lehman Foundation, Inc., which has established an eminent reputation with its sponsorship of special museum initiatives. We also are most grateful for the generous support of U.S. Bank, The Seattle Times, AT&T, United Airlines, IBM, and Corbis Corporation. Not only were Bill and Melinda Gates enthusiastic about sharing the Codex Leicester with the Seattle community, they also helped to fund the exhibition and educational programs.

From its inception the project has been shaped by two talented art historians, Chiyo Ishikawa, Curator of European Painting and Patterson Sims Fellow, and Trevor Fairbrother, Deputy Director of Art and Jon and Mary Shirley Curator of Modern Art. Working collaboratively, they tirelessly negotiated loans and produced the publication, imbuing it and the exhibition with energy, intelligence, and inventiveness. In the acknowledgments that follow, they thank their colleagues at the Seattle Art Museum and many others who have helped realize this project. I can only underscore my appreciation for the contributions of so many people. *Leonardo Lives* has been an extraordinary challenge to the entire staff of the museum, and I congratulate everyone on the tremendous dedication and unflagging good humor that they have shown.

Above all we are indebted to all our lenders. Through their generosity the works of Leonardo and his followers have been brought together in an exhibition that will surprise, inspire, and enlighten.

Mimi Gardner Gates
THE ILLSLEY BALL NORDSTROM DIRECTOR

Acknowledgments

Everyone at the Seattle Art Museum has worked hard to make this exhibition a success; it is a pleasure to be part of such a wonderful staff. We would especially like to thank the following colleagues who helped us with the curatorial aspects of *Leonardo Lives:* our director, Mimi Gardner Gates, whose encouragement, good faith, and high ambitions set the standard for this endeavor; Zora Hutlova Foy, exhibitions coordinator, who oversaw all details of the exhibition and catalogue with superb good humor, grace, and skill; Rock Hushka, our research associate, diligently and resourcefully gathered an enormous amount of material that contributed to the catalogue; Sue Bartlett, administrative assistant, helped in countless ways with thoroughness and good cheer. Michael McCafferty, exhibition designer, rose to the challenge of creating a coherent and beautiful exhibition that unites art from six centuries while incorporating computers, video, and a reading area. As registrar of the project, Lauren Tucker undertook the complicated task of assembling the exhibition; Gail Joice, senior deputy director for museum services, provided guidance on numerous logistical details. Paul Macapia oversaw several photography projects related to the exhibition. Elizabeth de Fato, librarian, was enormously generous with her time and help.

We are tremendously indebted to Maryann Jordan, deputy director for external affairs, who was energetic and remarkably successful in securing financial support for an exhibition of this scope. Her positive attitude was inspiring. Jill Rullkoetter, head of education, took a major role in making connections throughout the region to create an informal coalition of community partners; she also was in charge of the many educational programs and activities related to the show. Many more individuals worked incredibly hard in their areas of expertise to ensure our success: Jeff Eby, Vidette Falmo, Ashley Fosberg, Cecily Hennessy, Laura Hopkins, Jan Labyak, Gordon Lambert, Chris Lorraine, Carol Mabbott, Mary Ribesky, Jill Robinson, Ben Scholtz, Anne Treadwell, Heidi Walters, and Linda Williams.

To all the private and institutional lenders to *Leonardo Lives,* we offer our deepest appreciation. Their generosity will be greatly appreciated by everyone who sees this exhibition in Seattle. The exhibition benefited from the full and enthusiastic cooperation of many people and institutions. In particular we wish to thank: Maryan Ainsworth, Doris Ammann, Bill Begert, David Alan Brown, J. Carter Brown, Jan Crocker, Mary Beth Edelson, Melanie Goldstein, Margaret Morgan Grasselli, Diane De Grazia, Philip Isles, Beata Piasecka Johnson, Jennifer Jones, Laurence Kanter, Susan Kaye, Martin Kemp, Margery King, Bernd Klüser, Meg Malloy, Bridget Moore, Daisy Osborn, Carlo Pedretti, Melissa Posen, Bill Rathbun, Doug Rowan, Eva Schorr, Jena Scott, Elizabeth Shepherd, Natasha Sigmund, Timothy Standring, Gerard Stora, Monique van Dorp, Catherine Vare, David White, and Alfred Willis. We are delighted and honored by the beautiful publication produced by Marquand Books; we extend particular thanks to Ed Marquand, John Hubbard, and Suzanne Kotz.

Finally, we thank Lucy and Nap, Robert, and John for their love and support.

Trevor Fairbrother
Chiyo Ishikawa

SPONSORS' STATEMENTS

My late uncle Robert Lehman charged his Foundation with the task of continuing his support of the visual fine arts to fulfill his fervent wish that future generations be able to share his lifelong enjoyment of them. The Foundation's sponsorship of this exhibition implements his trust and will enable the museum's visitors to see works of art illustrating Leonardo da Vinci's genius and his influence on both modern and Old Master artists. The Foundation is honored to be associated with this exceptional exhibition, which celebrates an artist who not only embodied his own era but also inspired generations of artists who followed.

<div align="right">

Philip H. Isles, President
ROBERT LEHMAN FOUNDATION, INC.

</div>

U.S. Bank is honored to provide funding to bring this very special exhibition to the Seattle Art Museum. A rare and exciting opportunity to experience firsthand the genius of Leonardo, the viewing of the Codex Leicester is sure to inspire and enrich those who see it. We hope that this work, which embodies the innovative and creative potential of the human spirit, rekindles a sense of awe and discovery in us all.

<div align="right">

Phyllis J. Campbell, President
U.S. BANK, WASHINGTON

</div>

The Seattle Times is proud to be museum sponsor for *Leonardo Lives.* The exhibition showcases the profound contributions this great artist and visionary thinker made to our cultural heritage, and the tremendous vitality his work and ideas continue to have in our own time.

As a company, we benefit from an educated readership and believe in promoting and investing in education. The Seattle Times is excited to participate in what will be an enriching learning experience for our entire community.

We thank the Seattle Art Museum for mounting this show—and for contributing so much to our regional quality of life.

<div align="right">

Frank A. Blethen, Publisher and Chief Executive Officer
THE SEATTLE TIMES

</div>

Preface

When the Seattle Art Museum asked us to lend the Codex Leicester for this exhibition, Melinda and I knew it would be great for Seattle. After all, this is a city fueled by innovations in technology, aviation, and the arts. It is a city in which our daily lives are shaped by the forces of the sea, the mountains, and our region's natural history. Seattle's spirit of invention and commitment to the environment mirror Leonardo da Vinci's own passions, and in the Codex Leicester he examines issues that are relevant to all of us who live and work here.

Leonardo pursued knowledge with unrelenting energy. His scientific "notebooks" are awe inspiring not simply as repositories of his remarkable ideas but as records of a great mind at work. In the pages of the Codex Leicester, he frames important questions, tests concepts, confronts challenges, and strives for answers. He explores the effects of water on the earth and in the atmosphere, describes his observations on subjects ranging from astronomy to paleontology, and sketches practical inventions for strengthening bridges and controlling floods. His writings demonstrate that creativity drives discovery, and that art and science—often seen as opposites—can in fact inform and influence each other.

This process of cross-fertilization is at the heart of the exhibition at the Seattle Art Museum. It is also the source for an unprecedented collaboration among Seattle's cultural and educational institutions to present multidisciplinary programming on Leonardo's life, work, and enduring impact. Our community's response to this project is enormously gratifying.

I would like to thank the entire board and staff of the Seattle Art Museum for their hard work and dedication in organizing this exhibition. I have been fascinated by Leonardo da Vinci all my life, and Melinda and I sincerely hope that children and adults alike will also be inspired by this remarkable genius.

<div align="right">William H. Gates III</div>

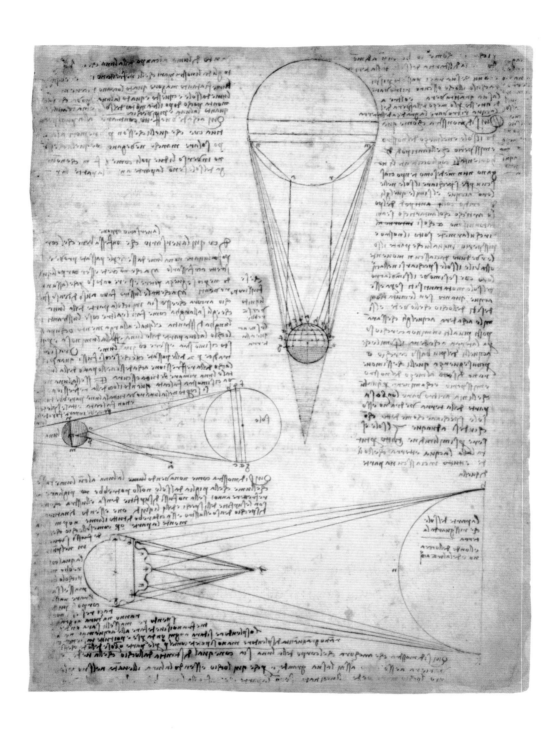

1 Leonardo da Vinci
Codex Leicester, c. 1508–10
folio 1r

Trevor Fairbrother
Chiyo Ishikawa

Leonardo da Vinci's Codex Leicester

Leonardo was born in Vinci, about twenty miles from Florence, in 1452. He began his study of art in Florence as an apprentice in the workshop of Andrea del Verrocchio (1435–1488). His precocious talents were evident in his first work (c. 1474–75), the beautiful kneeling angel in the foreground of Verrocchio's *Baptism of Christ* (Florence, Gallerie degli Uffizi). Around 1481 he wrote to Ludovico Sforza, the duke of Milan, offering his services as engineer, "master of instruments of war," architect, sculptor, and painter. Sforza employed Leonardo until 1499. During this lengthy period in Milan he also worked for other patrons and produced such acclaimed works as the *Virgin of the Rocks* (Paris, Musée du Louvre) and the *Last Supper* (Milan, Santa Maria delle Grazie). With the fall of the Sforza court in 1499 Leonardo left Milan and eventually returned to Florence (1500–8), where he painted the *Mona Lisa* (Paris, Musée du Louvre). During a second stay in Milan (1508–13) he painted the *Virgin and Child with Saint Anne* (Paris, Musée du Louvre) and made extensive studies of geometry and human anatomy; he also compiled the notes that comprise the Codex Leicester. The last six years of his life were more peripatetic, with sojourns in Rome (1514–16) and France (1517–19), where he was employed by the royal court of François I. He died in 1519 and was buried at Amboise.

LEONARDO'S MANUSCRIPTS

Throughout his career Leonardo kept extensive notebooks on a variety of subjects, including painting, anatomy, and technology. He apparently intended to publish at least two treatises, one on painting and another on mechanics, but he did not complete them. Leonardo bequeathed all his papers to his pupil and friend Francesco Melzi. At the end of the sixteenth century they came into the possession of the sculptor Pompeo Leoni, who took apart some of the notebooks and reassembled them by subject. Leoni's

well-intentioned efforts to impose thematic order on Leonardo's vast range of subjects created new difficulties of interpretation by destroying its original groupings and chronology.

It is estimated that a third of Leonardo's notebooks survive. The two largest bodies of material are now in the collection of the Biblioteca Ambrosiana, Milan, and the Royal Library, Windsor. The Codex Leicester is the only notebook by Leonardo remaining in private hands.

THE CODEX LEICESTER

My concern now is to find cases and inventions, gathering them as they occur to me; then I shall have them in order, placing those of the same kind together; therefore, you will not wonder nor will you laugh at me, Reader, if here I make such great jumps from one subject to the other. (folio 2v)

Like other notebooks by Leonardo, the manuscript now known as the Codex Leicester was a working record of observations, experiments, and arguments. Leonardo's occasional address to his "reader," however, as in the above quotation, indicates that he had publication in mind. The artist did not begin with a bound book of blank sheets; instead he conceived the notebook as an open file of large folded sheets to which he could continue to add. Devoted primarily to the nature and movement of water, the notebook addresses a variety of subjects whose range is indicated by citing just a few page headings: "Of the meeting of rivers and of their ebb and flow"; "Of the diversity of the waves of water"; "Of the water of the moon"; "Of the origin of rivers"; "Whether the earth is less than the water."

On the visually most spectacular page of the Codex Leicester (fig. 1), Leonardo diagrams three relationships between the sun, the earth, and the moon. The large vertical image concerns perceptions of the sun from particular positions on the earth. The other two drawings illustrate Leonardo's thoughts on the illumination of the moon. By the Renaissance it was commonly accepted that the moon had no light of its own but received reflected light from the sun; Leonardo now argued (erroneously) that water covered the outer sphere of the moon and that reflections from its waves allowed the moon to shine so brightly. The scalloped edge of the image in the bottom left represents waves on the surface of the moon.

Leonardo made more speculations about the moon's luminosity on a page headed "Of the waters of the moon" (fig. 2). He sought to explain why we

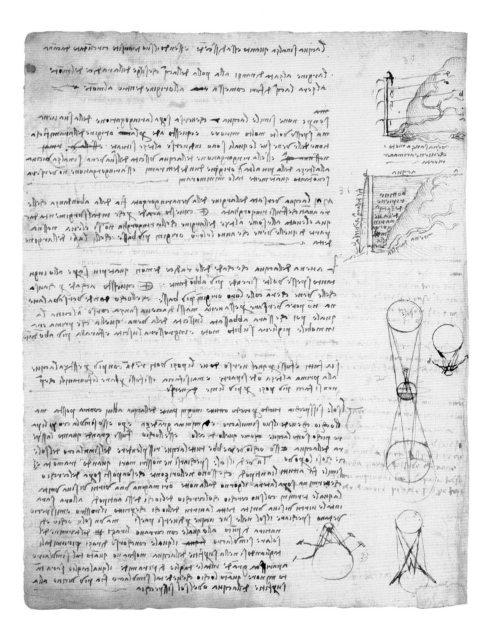

can see the entire body of the moon during its crescent phase, when only a small portion is brightly illuminated. In a large, geometrically bold diagram he shows how light from the sun hits the earth's oceans and is reflected back to the moon, faintly illuminating it. This lunar effect, a slender crescent of light beneath the dimly lit portion of the moon, is beautifully illustrated at the bottom of another page (frontispiece).

Leonardo's tendency to abruptly change subjects is evident in a page that jumps from a discussion of dams to the illumination of the moon (fig. 3). The two upper illustrations show the creation of a reservoir filled by damming up a spring at the base of a mountain. Leonardo describes and illustrates "veins" of water inside the mountain. He uses this anatomical analogy

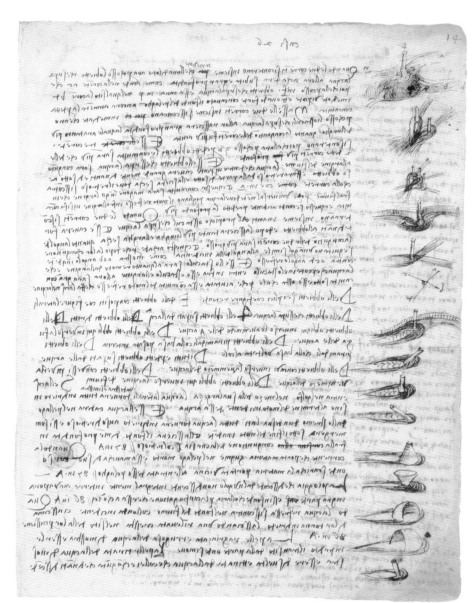

4 Folio 14r

elsewhere in the codex as, for example, in folio 33v: "The body of the earth, like the bodies of animals, is interwoven with a network of veins which are joined together, and are formed for the nutrition and vivification of the earth and of its creatures; and they originate in the depths of the sea, and there after many revolutions they have to return through the rivers formed by the high burstings of these veins."

Leonardo's abstract conception of the movement of water was balanced by a practical understanding of hydrodynamics, as seen in the fifteen marginal drawings on a page that discusses how water behaves when confronted with an obstacle (fig. 4). Putting this kind of knowledge to practical use on folio 32r (fig. 5), Leonardo outlined a complicated solution to protect a house

built close to the banks of a river. To prevent the water from eroding the building's foundation, Leonardo proposed a series of four dams to divert the river.

On a page titled "A confutation of those who say that shells were carried to a distance of many days' journey from the sea because of the Deluge" (folio 9v), Leonardo had a highly important geological insight. The mysterious presence of the fossils of sea creatures on the tops of mountains near Parma and Piacenza had long been a source of debate. Leonardo rejected the notion that they had been deposited there by the great flood described in the Book of Genesis and proposed that the surface of the mountains had once been the bottom of the sea: "And this may also be the reason why the marine shells and oysters which are seen in high mountains, and which have formerly been beneath the salt waters, are now found at so great a height, together with the stratified rocks" (folio 36r).

Leonardo suggested, on folio 4r, that water was also the key to the ancient question of why the sky is blue: "I say that the blue which is seen in the atmosphere is not its own color but is caused by the heated moisture having evaporated into the most minute, imperceptible particles, which the beams of the solar rays attract and cause to seem luminous against the deep, intense darkness of the region of fire that forms a covering above them."

THE HISTORY OF THE CODEX LEICESTER

The Codex Leicester may have been among the manuscripts bequeathed by Leonardo to Francesco Melzi, but its precise whereabouts were unknown until 1690, when the painter Giuseppe Ghezzi found the manuscript in Rome in a chest belonging to a Milanese sculptor, Guglielmo della Porta. Ghezzi owned the manuscript until 1717, when it was acquired by Thomas Coke, later earl of Leicester. In the eighteenth century, if not before, it was bound as a book. The codex remained at Holkham Hall, the Leicester estate, until December 12, 1980, when American businessman Armand Hammer bought it at auction at Christie's, London. He had the manuscript unbound, restoring it to its original state, and renamed it the Codex Hammer. After Hammer's death the manuscript was again sent to auction at Christie's, New York; Bill Gates purchased it on November 11, 1994, and restored the name Codex Leicester.

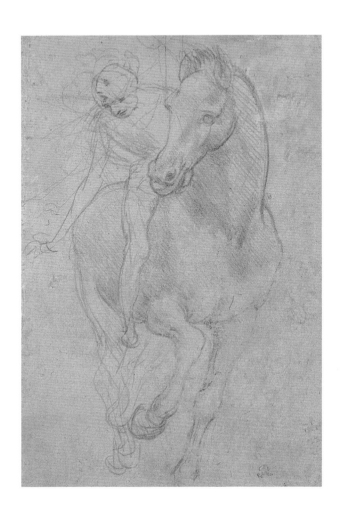

1 Leonardo da Vinci
A Horseman, c. 1480
cat. no. 21

Chiyo Ishikawa

Leonardo: Observer and Observed

"LEARN DILIGENCE BEFORE SPEEDY EXECUTION"

In the Codex Leicester Leonardo da Vinci rendered observations of natural phenomena in words, images, and diagrams. In this and other surviving manuscripts it is clear that he routinely followed observation with analysis. Leonardo's eyes, like those of anyone, instantaneously took in a given phenomenon—a storm gathering over a valley, or a stone hitting the surface of a puddle, for example. Unlike the casual observer, however, Leonardo then mentally dissected the experience and patiently recorded the sequential parts of the action he had so fleetingly seen. As he described, "We plainly know that sight is one of the swiftest actions that there is and that in one moment it takes in an infinite number of forms. Nevertheless it can only comprehend one thing at a time. . . . If you wish to have a true knowledge of the forms of objects you should commence with their details, and not pass on to the second stage until you already have the first committed to memory and well practiced. . . . Remember, learn diligence before speedy execution."[1]

Leonardo employed a combination of observation, analysis, and diligent recording of observed phenomena in all facets of his work. We are especially able to follow this pattern in his drawings, which vastly outnumber his twelve surviving painted works. More than any artist before the twentieth century, Leonardo revealed his complex and unruly creative process, whose elements—tentative original ideas for a project, compositional experiments and dead ends, changes of mind, and studies for individual figures—are perhaps even more fascinating to modern viewers than his finished, perfected works of art.

Leonardo applied his directive to study the relation of details to the whole in the numerous preparatory drawings he made for paintings. A metalpoint study of a horseman (fig. 1), for example, is one of many studies he executed in connection with the unfinished painting *The Adoration of the Magi* (fig. 2),

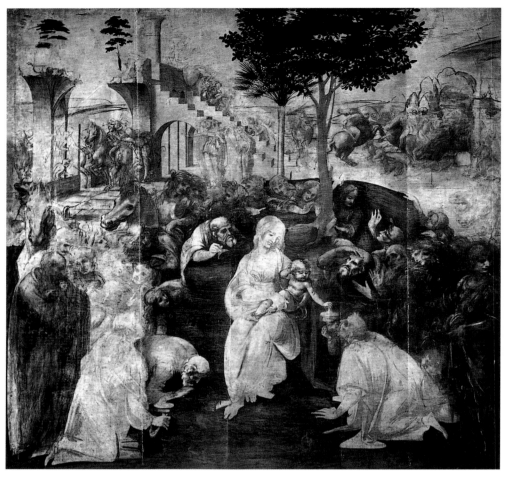

2 Leonardo da Vinci
Adoration of the Magi, 1480–81
Oil on panel
97 × 96 in.
Gallerie degli Uffizi, Florence

commissioned in 1480 or 1481 for the high altar of the monastery of San Donato a Scopeto, outside Florence.[2] The drawing shows a foreshortened horse with rider trotting toward the viewer with an easy freedom that re-minded one writer of "a dream visualized."[3] Leonardo experimented with the positioning of the head and right arm of the bareback rider, a slight figure leaning to one side. While the upper part of the horse is firmly mod-eled by Leonardo's characteristic fine parallel hatching, other parts are less resolved: the hind legs, for example, are only sketchily indicated.[4]

Ultimately, the horse so carefully studied in this drawing would play only a minor role in the painting. It appears riderless, in reverse, between two trees in the central background and again, also reversed, at the far left. The pres-ence of these and other standing, prancing, and rearing horses in the paint-ing may be related to the fact that the commission originated from the endowment of a saddle maker. The horses contribute to a tumultuous and emotionally charged atmosphere unusual in a representation of the Adora-

tion of the Magi, which traditionally was portrayed as a stately pageant of richly dressed kings and their entourages who have come to pay respect to the newborn Jesus.[5] In Leonardo's version participants appear to be not merely awed but overcome by their encounter with the Infant. The ambition of his plan apparently proved too great for the young artist, or other projects intervened: although Leonardo was given at least two years to complete the altarpiece, he abandoned his design and Florence itself for Milan, not to return for almost twenty years.

Like many of Leonardo's early drawings, the horseman was executed in metalpoint, a medium in which a metal stylus leaves marks on a paper that has been coated with an opaque preparation of ground bone, pigment, and water. The medium required great control. It was not possible to vary the

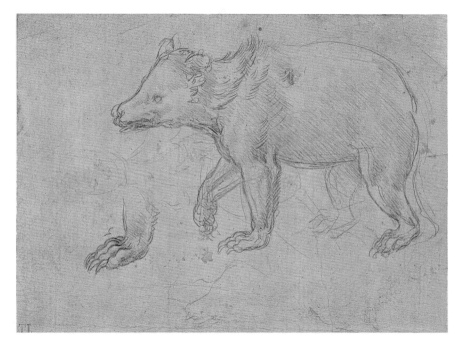

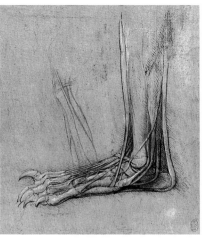

3 Leonardo da Vinci
Study of a Bear Walking, c. 1490
cat. no. 23

4 Leonardo da Vinci
A Bear's Leg Dissected, c. 1490
Metalpoint and pen and ink, with white
heightening, on prepared paper
6⅜ × 5⅜ in.
Royal Library, Windsor Castle

width of the drawn stroke, as when using charcoal or a brush, so artists had to rely on meticulous hatching to convey shadow and modeling. In addition, marks could not be erased without scraping away the ground and repriming the paper. That is why we see Leonardo's experiments in positioning the horseman's head and the rear legs of the horse in the San Donato study. It is also the likely explanation for the faint presence of a seated woman that appears beneath a metalpoint study by Leonardo of a bear, now in the Lehman Collection (fig. 3). Paper was extremely expensive and artists commonly reused it, drawing right over abandoned designs.

The drawing of the walking bear, one of several surviving studies of bears and their anatomy by Leonardo, is unique in its summation of the outer form and character of the animal, capturing its tentative step, compact proportions, bony feet, and long claws. Regular hatching strokes rake across the surface but do not follow the contours of the body, a technique seen in the horse's body in the study for the San Donato altarpiece (fig. 1). A few wispy, curving strokes suggest the coarse fur around the neck, back, and forelegs, but for the hindquarters Leonardo was more interested in describing the underlying structure than surface covering.

In another metalpoint drawing probably made about the same time (fig. 4), Leonardo drew a dissected bear leg to analyze how skeleton, muscles, and tendons worked together. The sustained discipline and measured analysis seen in this drawing show a different kind of observation from the more impressionistic drawing of the bear's complete figure. The searching for proper proportions and arrangement of the legs in the lively animal of the Lehman drawing signal a completely different enterprise from the cool analysis of a limb that, after all, is no longer alive.

Leonardo would have come to an understanding of the relation between structure and form with the help of his teacher, the painter and sculptor Andrea del Verrocchio (1435–1488). Verrocchio's brilliant portrait study of a bishop (fig. 5) demonstrates a working method Leonardo knew well. The drawing was a *modello,* or sketch, for the only documented painting in Verrocchio's career, a Virgin and Child with John the Baptist and Saint Donatus, which is still in the Pistoia cathedral (fig. 6). The altarpiece was commissioned about 1479 following instructions in the will of Donato de' Medici, bishop of Pistoia, who before his death in 1474 had made elaborate plans for the construction of a chapel dedicated to the Virgin within the cathedral.[6] As was common at the time, the donor is portrayed as his name saint in the painting, and Verrocchio's meticulous and lifelike image of Saint Donatus may be based on a portrait bust made from the death mask of Donato de' Medici.

Painted on a fine linen prepared with a ground, the portrait is so highly finished that a modern viewer might not readily imagine it as a preparatory sketch. But such thoroughness of description would have been useful if a

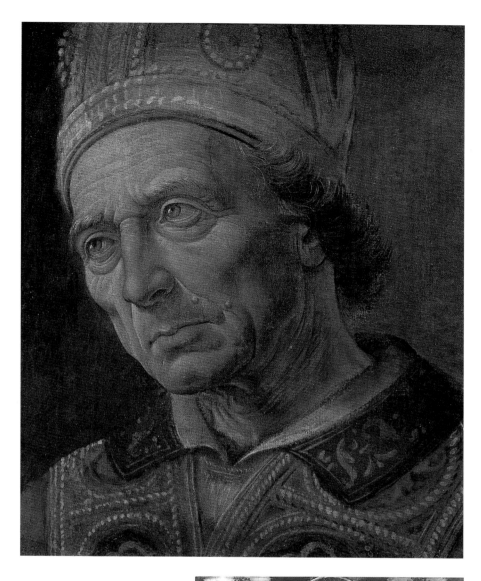

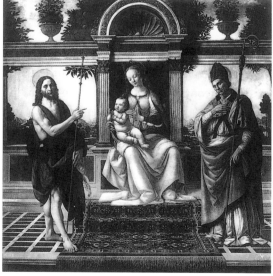

5 Andrea del Verrocchio
Saint Donatus, c. 1479
cat. no. 44

6 Andrea del Verrocchio and Lorenzo di Credi
*Virgin Enthroned between Saint John the
Baptist and Saint Donatus,* c. 1479
Oil on wood panel
74⅜ × 75¼ in.
Duomo, Chapel of the Sacrament, Pistoia

member of Verrocchio's workshop, rather than the master himself, painted the complete figure for the altarpiece. Indeed, most scholars now believe that Lorenzo di Credi (c. 1457–1536), a pupil of Verrocchio, carried out most, if not all, of the painting.[7]

Verrocchio's meticulous portrait, with its tight, fine brushstrokes, exemplifies the rigorous observation and exhaustive descriptiveness that we also witness in Leonardo's work. Verrocchio's handling of the bishop's head proceeds from his knowledge of the sculptural structure of the skull, which supports the sagging flesh of the bishop. At the same time, the surface of the skin itself is described in terms of line, from the dark contours that trace the left edge of the face, the right side of the neck, and the line between the lips, to the myriad wrinkles that turn the aged cleric's face into a map of sadness or of deep faith. Verrocchio's contemporaries would have considered this extremely linear treatment suitable for the portrayal of an old man. In his treatise on painting, Leonardo described a conventional picture of age: "Old men will have rough and wrinkled surfaces, venous and with prominent sinews."[8] But in his comparably haggard *Saint Jerome* (fig. 7), an unfinished painting from a few years later, Leonardo favored broader modeling in light and dark to convey the same kind of ropy, weathered figure. From his earliest paintings Leonardo abandoned the enclosing contour line used by artists of the previous generation, believing it gave a wooden look, and replaced it with *sfumato* (literally, "smoky") modeling that blurred the edges of forms and more convincingly conveyed three-dimensionality.[9]

The unusual medium of tempera on linen prepared with a colored ground in the Verrocchio *modello* is identical to that used in sixteen mono-

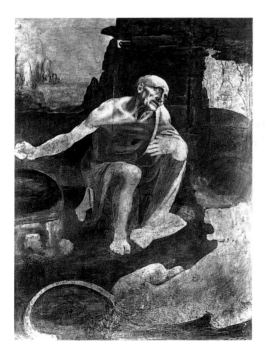

7 Leonardo da Vinci
Saint Jerome, c. 1481–82
Oil on panel
40½ × 29½ in.
Pinacoteca Vaticana, Rome

8 Leonardo da Vinci
Drapery Study of Kneeling Figure Facing Left, c. 1470
cat. no. 19

9 Leonardo da Vinci
Drapery Study of Standing Figure Facing Right,
c. 1470
cat. no. 20

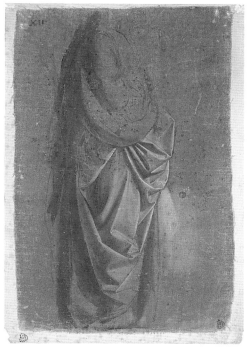

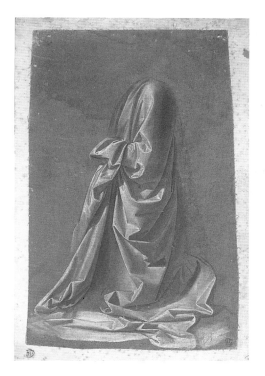

chrome drapery studies which have been associated with both Verrocchio and Leonardo (figs. 8, 9).[10] In his life of Leonardo (1568 edition), Giorgio Vasari described Leonardo's practice around the time he was working with Verrocchio: "He studied much in drawing after nature, and sometimes in making models of figures in clay, over which he would lay soft pieces of cloth dipped in clay, and then set himself patiently to draw them on a certain kind of very fine Rheims cloth, or prepared linen: and he executed them in black and white with the point of his brush, so that it was a marvel, as some of them by his hand, which I have in our book of drawings, still bear witness."[11]

In the superb drawing of a kneeling figure (fig. 8), Leonardo accentuated the sharp facets and pockets of shadow that resulted from the gathering up of the fine, crisp cloth. The sharp angles and strong contrasts of light and dark create an effect comparable to the drapery of the angel that the young Leonardo added to Verrocchio's *Baptism of Christ* (Florence, Gallerie degli Uffizi).[12] In his later paintings (fig. 18, for example), Leonardo would design drapery that conformed much more closely to the body beneath, and he would abandon the complicated folds that emphasize surface pattern at the

expense of volume. As he wrote in later years: "The draperies that clothe figures must show that they are inhabited by these figures, enveloping them neatly to show the posture and motion of such figures, and avoiding the confusion of many folds."[13]

In the drawing of a standing figure (fig. 9), however, we do sense the presence of an imposing form beneath the drapery, which falls into great sweeping folds that give the composition a monumental character. The study, one of several views of what seems to be the same standing draped figure, has some of the presence of the brooding figure at the left of Leonardo's *Adoration of the Magi* (fig. 2).[14] Rather than studies for particular works, however, these sixteen drawings apparently were exercises in creating, intensely scrutinizing, and precisely rendering the complicated drapery arrangements that were part of the repertoire of the Renaissance artist. The concentration and brilliance with which they were rendered are typical of the prodigious artist's earliest works.

"IF YOU MUST HAVE COMPANY, CHOOSE IT FROM WITHIN YOUR STUDIO"[15]

If Verrocchio's rendering of Donato de' Medici followed a decorous treatment of an old man, a painting by Leonardo's contemporary and sometime collaborator in Milan, Ambrogio de Predis (c. 1455–c. 1508?), creates a picture of youth that also conforms to conventions of age (fig. 10). Leonardo wrote: "Youths have limbs with small muscles and blood vessels, and the surfaces of the body are delicate and rounded and of agreeable color."[16] The soft, blended modeling of contours stands in marked contrast to Verrocchio's treatment of the face of Donato de' Medici.

The image is considered to be a portrait of a young man in the guise of Saint Sebastian, an early martyr (said to be born in Milan and therefore popular there) who was shot by arrows before being drowned. The contemporary costume would indeed be expected in a portrait, but the figure itself is sufficiently idealized to be read as a type rather than an individual. The boy has all the hallmarks of a Leonardo angel: youth, androgyny, an enigmatic and sweet half-smile, curly hair that catches the light, and prominent, expressive hands.[17]

The torso of the youth angles to one side as his head turns to receive the light falling from the right. His elegant hands gesture delicately, seemingly in response to something outside the picture. His subtle facial expression as well as the suggestion that he can both move within the pictorial space and respond to external stimulation contributes to the impression that he is alive. The boldness of this conception is clear when compared with the more static Milanese portrait formula that Ambrogio had already mastered.[18] Most Milanese portraits at the turn of the century show the sitter in profile against a plain background, as in an image by Bernardino de' Conti (c. 1470–after 1523) of Charles d'Amboise, duke of Chaumont, the French governor of

10 Ambrogio de Predis
*Portrait of a Youth as Saint
Sebastian,* c. 1494
cat. no. 30

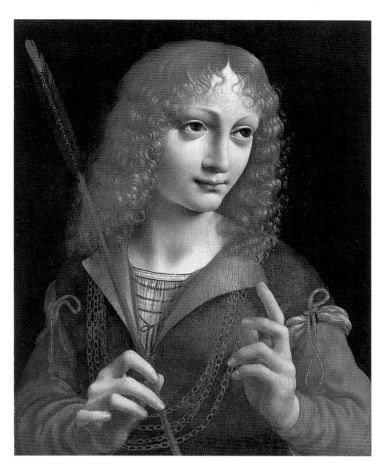

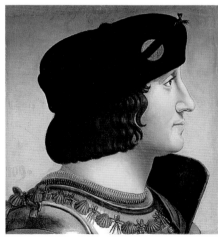

11 Bernardino de' Conti
Portrait of Charles d'Amboise, c. 1505
cat. no. 9

12 Leonardo da Vinci
*Portrait of a Lady with an Ermine (Cecilia
Gallerani),* c. 1483–85
Oil on panel
21 × 15½ in.
Czartoryski Collection, Kraków

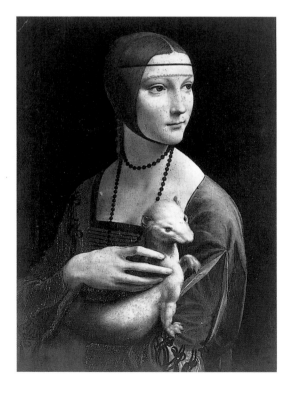

Milan (fig. 11). The painting reveals nothing of the sitter's personality but displays clues about his social status, wealth, and personal interests: the collar of scallop shells and knots represents the Order of Saint Michael, granted to him about 1505; the coin adorning his black hat symbolizes his collection of ancient coins; and the profile view itself recalls ancient coins and medals, implying a link between a contemporary governor and the great rulers of the past.[19]

The more animated composition of the portrait by Ambrogio de Predis directly reflects Leonardo da Vinci's innovations in imparting life to the sitter, which are exemplified by his enchanting portrait of Cecilia Gallerani (fig. 12), ordered by Ludovico Sforza, duke of Milan, in the 1480s. The two artists knew each other and worked at the Sforza court.[20] In addition, Ambrogio, his brother Evangelista, and Leonardo shared a commission by the Confraternity of the Immaculate Conception to create an altarpiece whose central panel was the painting known as the *Virgin of the Rocks.*[21] Scholars continue to debate the extent of Ambrogio's participation in the painting, but if he did collaborate with Leonardo, Ambrogio would have needed to submerge his earlier instincts in conformation to Leonardo's more modern style, something he managed handily in the portrait of the youth.

In transforming the Milanese portrait formula, Leonardo must have been familiar with the innovations of Flemish portraitists, who as early as the 1430s had depicted sitters full-face and with gesturing hands.[22] Though rarely discussed in scholarly studies, it is likely that Leonardo and his circle were well aware of fifteenth-century Flemish painting. A beautiful *Virgin and Child with Columbines* now in Denver (fig. 13), for example, displays a familiarity with the work of the Bruges painter Hans Memlinc, who painted many similar Madonnas accompanied by objects with symbolic value.[23] Because they had seven flowers on each stalk, for example, columbines were a familiar symbol throughout Europe of the seven gifts of the Holy Spirit and also of the Seven Sorrows of the Virgin.[24]

If its composition, iconography, and saturated coloring reflect contemporary northern painting, however, the pearly modeling of the baby's flesh and the Virgin's tilted head and half-closed eyes are unthinkable without the example of Leonardo, who early in his career had painted intimate images of the Virgin and Child playing with flowers in a domestic interior (Munich, Alte Pinakothek; Saint Petersburg, Hermitage Museum). In the Denver painting, the Virgin's loose-flowing hair and timelessly simple garment have parallels in the design for the *Virgin of the Rocks* of c. 1483–86 (Paris, Musée du Louvre) or even in the *Last Supper* (fig. 19), where the inclining, introspective head of John the Evangelist resembles that of the Virgin here. The painting can also be related to Leonardo's design for the *Virgin and Child with a Yarnwinder* (c. 1501) in its motif of the Virgin gently restraining the playful Christ Child.[25]

In addition to collaborators like Ambrogio, Leonardo had workshop assistants who painted under his supervision, with his occasional participation.[26] The Lombard artists most influenced by him include Marco d'Oggiono, Giovanni Antonio Boltraffio, Andrea Solario, Bernardino Luini, and Giampietrino. Some, like Salaì and Francesco Melzi, discussed in more detail below, were members of Leonardo's household who worked and traveled with him.

"EVERYTHING THAT CAN BE TAKEN IN BY THE EYES"[27]

In his writing, as in his art, Leonardo continually moved between the particular and the universal, and between traditional thinking and new ideas based on direct observation. He encouraged the young artist to be an "imitator of nature" and to notice that "among the praiseworthy and marvelous things which are apparent in the works of nature, it happens that none of the productions of any species in themselves precisely resemble in any of their details those of any other."[28] In the next sentence, however, he cautioned, "I will be well pleased if you avoid monstrous things, like long legs with short torsos, and narrow chests with long arms." Leonardo evidently believed that the student should recognize and study the variety of forms in nature, but to compose pleasing paintings, the artist should impose traditional norms of proportion and harmony—in other words, modify random observations according to an intellectual process founded on knowledge and

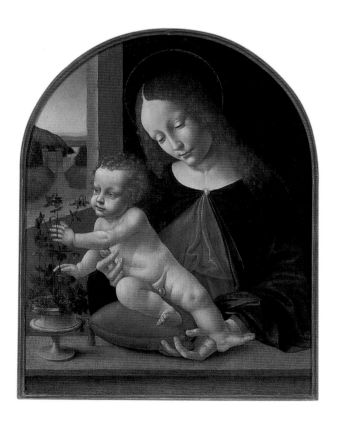

13 Circle of Leonardo da Vinci
Virgin and Child with Columbines,
c. 1497–98
cat. no. 25

judgment. Indeed, the dozen or so surviving paintings by Leonardo are composed according to these principles, and they exhibit, over the course of his career, an increasingly rarefied distillation of the elements of beauty and harmony. The drawings, however, contain all the variety of nature itself, exhibiting a bewildering and wonderful range of sizes, media, subjects, and expressions.

A tiny pen-and-ink drawing of a wizened woman from the Woodner Collection (fig. 14) could not be further from the idealized types that populate Leonardo's paintings, and it recalls his description of how to portray aged women: "Old women should be represented as shrewlike and eager, with irascible movements in the manner of the infernal furies."[29] Leonardo applied the dignified profile formula of Lombard portrait painting to a hunched, fierce dowager whose coquettishly low bodice and elaborate, veiled coiffure grotesquely set off her sagging, crepey flesh. The most absurd detail, comical and sad at once, is the fresh carnation tucked perkily into her bodice. The carnation was a common symbol of betrothal and thus associated with youthful promise and romance.[30]

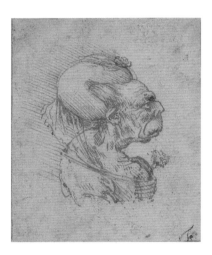

14 Leonardo da Vinci
Grotesque Head of an Old Woman, 1489–90
cat. no. 22

Exaggerated caricatures of real physical types and grotesque heads born of fantasy make up a large proportion of surviving drawings by Leonardo. So different from his searching compositional studies, or the sustained scrutiny of the anatomical drawings, they have aroused considerable debate among scholars regarding their original function, if any. As Carlo Pedretti has demonstrated, many of them were originally marginal drawings on sheets devoted to unrelated subjects. At the end of the sixteenth century, in an attempt to organize Leonardo's drawings, Pompeo Leoni cut the grotesques from pages containing technological studies and placed them with art and anatomy drawings.[31] They may be mere doodles that recorded the semiautomatic jottings of the artist, but they have also been seen as Aristotelian ruminations on the relation between outward appearance and inner

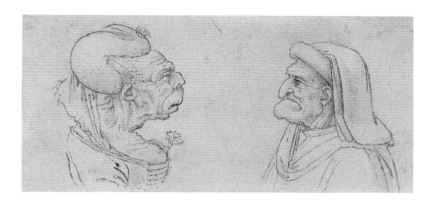

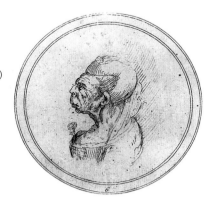

15 Francesco Melzi
Two Grotesque Heads (after Leonardo), c. 1510(?)
cat. no. 27

16 Anne-Claude Philippe, comte de Caylus
Plate 6 from *Recueil de testes de caractère et
de charges dessinées par Léonard de Vinci*, 1730
Engraving on paper
3⅜ in. diam.
The Elmer Belt Library of Vinciana, University of
California at Los Angeles

character, or productions in keeping with the courtly taste for riddles, jests, and clever wordplay.[32]

Whatever their purpose, the grotesques were among the most popular works of Leonardo and in subsequent years were copied more frequently than his drawn figure studies or inventions. His pupil Francesco Melzi (1491/3–c. 1570), who inherited most of Leonardo's notebooks, papers, and drawings, made multiple copies of the grotesques, often arranging them in pairs or groups on a page (fig. 15).[33] This sequencing invited nineteenth-century interpretations of the grotesques as part of a projected systematic study of physiognomy, but this construal probably has little to do with Leonardo's own intentions. Copies of original Leonardo grotesques in turn became models for engraved versions by Wenceslaus Hollar, in the early seventeenth century, and, in the next century, by Anne-Claude Philippe, the comte de Caylus (1692–1767; fig. 16).

In the caricature of the old lady seen at the left side of figure 15, Melzi faithfully transcribed the individual marks of Leonardo's drawing but his touch is dry and careful, and the overall effect is softer and less incisive. A fundamental difference is in the treatment of the eyes: where Leonardo's woman is wide-eyed and staring, Melzi modified the lower eyelid so that she looks long-suffering rather than ferocious. The Caylus engraving, twice removed from the original, rounds the nose, turns the gaze upward, and softens the line of the mouth. The woman is suddenly ennobled, and the engraved circular frame completes her elevation.

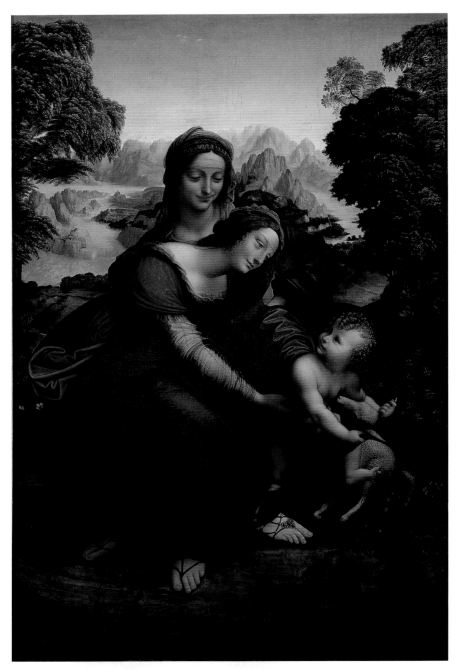

17 Salai (Gian Giacomo Caprotti di Oreno)
Virgin and Child with Saint Anne (after Leonardo),
c. 1520
cat. no. 36

Leonardo's exalted reputation, already widespread during his lifetime, was secured by Vasari's mythicizing biography (written 1550 and revised 1568), which increased the artist's fame despite the fact that little of his artistic output was accessible to general view.[34] That other artists held Leonardo in high regard is amply demonstrated by the many works of art directly influenced by his paintings even in his lifetime and well before the invention of photography made them accessible to all (for Leonardo's influence on twentieth-century artists, see the following essay).

A first example is a direct copy of Leonardo's *Virgin and Child with Saint Anne,* painted by perhaps his most faithful pupil, Gian Giacomo Caprotti di Oreno, called Salaì (c. 1480–1524). Best known in the Leonardo literature as the "thief, liar, obstinate, glutton" who came to live with Leonardo in 1490 at the age of ten, Salaì stayed until the master's death in 1519.[35] Vasari reported that Salaì was "most comely in grace and beauty, having fine locks, curling in ringlets, in which Leonardo greatly delighted; and he taught him many things of art; and certain works in Milan, which are said to be by Salaì, were retouched by Leonardo."[36]

The copy (fig. 17), originally in the sacristy of Santa Maria presso San Celso in Milan, has been attributed to Salaì since the eighteenth century, though seventeenth-century writers believed it was by Leonardo himself.[37] We know nothing of a commission for Leonardo's original painting (fig. 18), now in the Louvre, but its presence in an inventory of Salaì's possessions, compiled after his death, suggests that he had received it from Leonardo.[38]

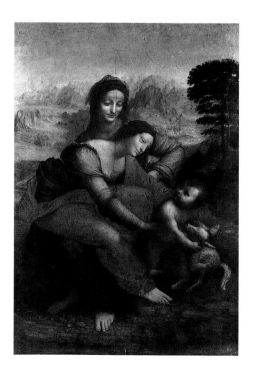

18 Leonardo da Vinci
Virgin and Child with Saint Anne,
c. 1508–13
Oil on wood panel
66⅛ × 44⅛ in.
Musée du Louvre, Paris

Direct access to Leonardo's painting would explain the faithful correspondence between the two images. The only major compositional departure is Salaì's addition of full, leafy trees, which frame the central figural group but obscure the distant landscape that is one of the most celebrated features of Leonardo's original. Salaì also added columbines and strawberry plants, which make the scene more intimate and impart symbolic content. The columbine, as we have seen, is associated with sorrows of the Virgin Mary. The strawberry is another Marian symbol because its seeds are not on the inside of the fruit. All these additions give the picture a slightly more Flemish character and may have been ordered by the patron.

Leonardo painted his version at the same time he was compiling the Codex Leicester, and even in Salaì's less atmospheric copy we can observe signs of the scientific concerns that then occupied him. These included the aerial perspective by which objects become paler and less distinct the farther they are from the viewer, and the blueness of the sky, which Leonardo analyzed in the Codex Leicester as follows: "The atmosphere acquires its blueness from the particles [of moisture] which catch the luminous rays of the sun" (folio 4v). Finally, the dramatic landscape of the painting can be seen as an image of the earth's vitality as described in the codex: "We may say that the earth has a spirit of growth. . . . Grass grows in the fields, leaves upon the trees, and every year these are renewed in great part" (folio 34r).

Salaì's copy is extremely accomplished, and although it hardens the filmy qualities of the original, it may give a truer account of its coloring, which is barely visible under layers of discolored varnish. The later painting would have been appreciated in its time not only for its association with Leonardo (we do not know, after all, whether Leonardo's painting was widely known

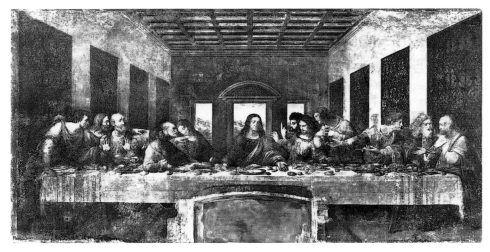

19 Leonardo da Vinci
The Last Supper, c. 1495–98
Wall painting
15 × 29 ft.
Santa Maria delle Grazie, Milan

in Milan) but for its intrinsic sweetness, celebration of the Virgin, and high degree of finish. It is useful to remember that although the nineteenth century has given us a definition of the Italian Renaissance as a period of constant artistic innovation and individuation, artists employed workshop painters to meet demand, and there was clearly also a ready market for copies. Leonardo's own advice, "I say to painters that no one should ever imitate the style of another," was directed to masters—"those who by this art seek honour and renown"—and not assistants such as Salaì.[39]

A final example, demonstrating a different kind of emulation, stems from a faithful contemporary copy of Leonardo's *Last Supper* (fig. 19). Painted for the refectory of a Milanese monastery, the wall painting was the one widely accessible work by Leonardo and therefore famous from the time it was completed. Not surprisingly, it was the subject of one of the earliest reproductive engravings in Italy (fig. 20). Giovanni Pietro da Birago (fl. c. 1471/4–1513), an artist employed by the Sforza court as an illuminator and engraver, made his print shortly after Leonardo completed the wall painting. He preserved the clarity of Leonardo's design, which in the original has become obscured by condition problems and many restoration attempts.[40] Small variations in the engraving, such as the replacement of eight dark tapestries by simple rectangular outlines, do not distract from the overall impact of the stately but dramatic composition. Birago retained Leonardo's own emphasis on the varied reactions of the disciples to Christ's announcement that one of them would betray him.[41] A surprising addition to the composition is a small dog gnawing on a bone at the bottom right, a playful genre element completely out of keeping with the spirit of the original but a typical feature of Birago's manuscript illuminations for the Sforza court.

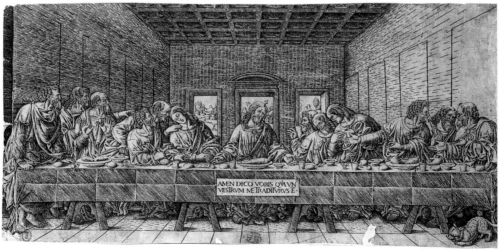

20 Giovanni Pietro da Birago
The Last Supper (after Leonardo), after 1498
cat. no. 6

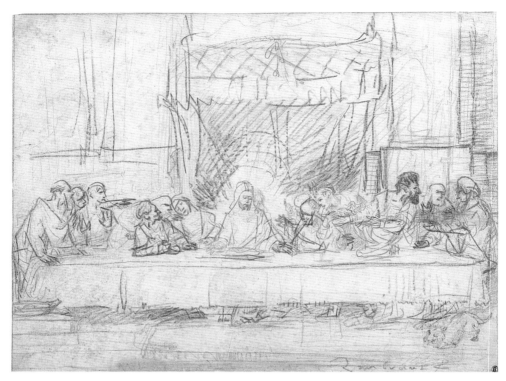

21 Rembrandt van Rijn
The Last Supper (after Leonardo), c. 1635
cat. no. 34

The engraving is rare today—only seven impressions are known to ex-
ist—but in the sixteenth and seventeenth centuries it helped spread the fame
of Leonardo's masterpiece to parts of Europe where original works by him
were not to be seen. Artists who knew only northern Europe would have
been acquainted with the work of earlier Italian masters through literary
accounts, local painting collections, descriptions by travelers, and such
prints. We know, for example, that an impression of Birago's *Last Supper*
was owned by Rembrandt (1606–1669), an artist who never left his native
Netherlands and is not automatically associated with Leonardo. In the
1630s Rembrandt made three powerful red chalk drawings based on the
print by Birago.[42] Of the three, the first (fig. 21), in the Lehman Collection,
is the closest adaptation of the Italian engraving, including even the dog
(which seems more at home in a Dutch drawing). Still, differences are im-
mediately evident. Rembrandt completely altered the setting, eliminating
Leonardo's perspectival box and replacing it with a large baroque canopy
that lends height and majesty, but not depth, to the setting.

The drawing was executed in two stages. The first was a fairly faithful,
careful rendering of the figures in the engraving. Over this, with bolder,
heavier strokes, Rembrandt emphasized certain figures and made a few
changes—most notably in the figure of Christ, who is more upright in the
revision. Rembrandt apparently was trying to understand how Leonardo

created small pockets of drama without losing the unity of the overall com-
position. The multiple outlines caused by Rembrandt's repositioning of
some of the figures recall Leonardo's searching for the final pose of horse and
rider in the San Donato study (fig. 1). Rembrandt never painted a faithful
copy of the *Last Supper,* but this exercise, an example of close observa-
tion and analysis in the manner of Leonardo's own studies, would have an
impact on Rembrandt's later compositions such as the *Supper at Emmaus*
(1648; Paris, Musée du Louvre) and the *Conspiracy of Claudius Civilis* (1661;
Stockholm, Nationalmuseum).

With this final example of Leonardo's early influence, we have moved
from contemporary renderings of what would have been the latest sensation
in art to something more complicated. In Rembrandt's copy of the *Last Sup-
per* we can identify a spirit of homage, to be sure, but perhaps also a sense of
artistic competition in which a well-known, established, ambitious artist
takes on the most celebrated artist of an earlier age and even makes slight
"improvements" on his work. In this sense, Rembrandt's drawing anticipates
the complex range of later responses that would make the twentieth century
a renaissance for Leonardo.

NOTES

1. Martin Kemp, ed., *Leonardo on Painting: An Anthology of Writings by Leonardo
da Vinci with a Selection of Documents Relating to His Career as an Artist* (New
Haven: Yale University Press, 1989), p. 197.

2. See Martin Clayton, *Leonardo da Vinci: A Singular Vision* (New York: Abbeville
Press, 1996), p. 25, for a discussion of the dating of this painting.

3. Patricia Trutty-Coohill, *The Drawings of Leonardo da Vinci and His Circle
in America,* arranged and introduced by Carlo Pedretti (Florence: Giunti, 1993),
p. 37.

4. The horse and rider appear again in a drawing in the Clarke Collection, Cam-
bridge; see Kenneth Clark, *Leonardo da Vinci* (1939; rev. ed., London: Penguin
Books, 1993), p. 75, fig. 23.

5. Compare, for example, the famous *Adoration of the Magi* by Gentile da Fabriano
in the Gallerie degli Uffizi, Florence, illustrated in Frederick Hartt, *History of Italian
Renaissance Art,* 3rd ed. (New York: Harry N. Abrams, 1987), colorplate 22.

6. For a thorough discussion of this project, see Martin Kemp, "Verrocchio's 'San
Donato' and the Chiesina della Vergine di Piazza in Pistoia," forthcoming. I am
grateful to Professor Kemp for making an advance draft of the article available
to me.

7. Ibid. G. Passavant, *Verrocchio: Sculptures, Paintings and Drawings* (London:
Phaidon Press, 1969), app. 44, attributed a drawing for the standing figure of the
bishop in the National Gallery, Edinburgh, to Credi (Kemp, "Verrocchio's 'San
Donato,'" believes it may be by Verrocchio himself).

8. Kemp, *Leonardo on Painting,* p. 132.

9. "When you represent in your work shadows which you can only discern with dif-
ficulty, and of which you cannot distinguish the edges so that you apprehend them
confusedly, you must not make them sharp or definite lest your work should have a
wooden effect"; see Jean Paul Richter, *The Notebooks of Leonardo da Vinci,* vol. 1
(1883; reprint, New York: Dover Publications, 1970), p. 132, §236.

10. *Léonard de Vinci, Les études de draperie* (exh. cat.), Musée du Louvre (Paris:
Editions Herscher, 1989) attributed all sixteen drawings to Leonardo; see also the
review by David Scrase, *Burlington Magazine* 132 (1990), pp. 151–54. Jean K.
Cadogan, "Linen Drapery Studies by Verrocchio, Leonardo and Ghirlandaio,"
Zeitschrift für Kunstgeschichte 46 (1983), pp. 27–62, proposes a division of

hands among artists in Verrocchio's workshop. Keith Christiansen, "Leonardo's Drapery Studies," *Burlington Magazine* 132 (1990), pp. 572–73, agrees with Cadogan's premise of a division of hands but disagrees on individual attributions.

11. Giorgio Vasari, *Lives of the Most Eminent Painters, Sculptors and Architects,* trans. Gaston du C. DeVere (1568; London: Medici Society, 1912–14), p. 90 (hereafter cited as *Lives of the Artists*).

12. Passavant, *Verrocchio,* figs. 78, 82.

13. Kemp, *Leonardo on Painting,* p. 153.

14. Christiansen, "Leonardo's Drapery Studies," p. 573, associated this and related drawings to Verrocchio's sculpture of the resurrected Christ in *The Doubting Thomas* made for Or San Michele in Florence, though he acknowledged that "the analytic mind to which they testify is scarcely inferior to that of the young Leonardo."

15. Kemp, *Leonardo on Painting,* p. 205.

16. Ibid., p. 132.

17. Shortly after his arrival in Milan Leonardo compiled an inventory of his early works which lists "8 Saint Sebastians" (Kemp, *Leonardo on Painting,* p. 263). It would be interesting to know if any of the eight images related to Ambrogio's painting, but they are apparently lost.

18. See, for example, his portrait of Bianca Maria Sforza, c. 1493, illustrated in Fern Rusk Shapley, *Catalogue of the Italian Paintings* (Washington, D.C.: National Gallery of Art, 1979), vol. 1, pp. 380–82, and vol. 2, pl. 275.

19. Charles d'Amboise, as governor of Milan, employed Leonardo to undertake architectural and painting projects between 1508 and 1511, the year of Charles's death. It is therefore somewhat surprising that he would not have commissioned a portrait from Leonardo himself.

20. Ambrogio was named court painter in 1482, shortly before Leonardo arrived in Milan to work for Ludovico Sforza.

21. The central panel of the altarpiece survives in two versions (one in the Louvre, Paris, and one in the National Gallery, London). For two useful discussions of their complicated history, see Clark, *Leonardo da Vinci,* pp. 30, 90–98, 201–4, and Martin Kemp, *Leonardo da Vinci: The Marvellous Works of Nature and Man* (London: J. M. Dent and Sons, 1981), pp. 93–99.

22. See, for example, Jan van Eyck's *Tymotheos,* 1432, National Gallery, London, illustrated in James Snyder, *Northern Renaissance Art* (New York: Harry N. Abrams, 1985), p. 97, fig. 95.

23. For a comparable image by Memlinc, see ibid., p. 183, fig. 143.

24. Columbines appear most famously in the Portinari altarpiece by Hugo van der Goes, painted for Santa Maria Nuova in Florence. For their symbolism, see Erwin Panofsky, *Early Netherlandish Painting,* vol. 1 (Cambridge: Harvard University Press, 1953), p. 146, n. 6.

25. Illustrated in Clark, *Leonardo da Vinci,* p. 168, fig. 64.

26. Fra Pietro da Novellara, who visited Leonardo's workshop in Florence in 1501, reported to Isabella d'Este that "two of his apprentices are making copies and he puts his hand to one of them from time to time" (letter dated April 3, 1501, quoted in Kemp, *Leonardo on Painting,* p. 273).

27. Ibid., p. 201.

28. Ibid., p. 119.

29. Ibid., p. 147.

30. In the portrait of Bianca Sforza by Ambrogio de Predis (see n. 18), for example, the sitter wears a carnation tucked in her belt.

31. Carlo Pedretti, *Leonardo da Vinci: Fragments at Windsor Castle from the Codex Atlanticus* (London: Phaidon, 1957). For a concise summary of the grotesques and their critical reception, see A. Richard Turner, *Inventing Leonardo* (Berkeley: University of California Press, 1992), pp. 76–83.

32. For examples of these divergent views, see Clark, *Leonardo da Vinci,* pp. 120–21; Michael W. Kwakkelstein, *Leonardo da Vinci as Physiognomist: Theory and Drawing Practice* (Leiden: Primavera Pers,1994), pp. 30ff; Pietro C. Marani, in *The Touch of the Artist: Master Drawings from the Woodner Collections* (Washington, D.C.: National Gallery of Art, dist. by Harry N. Abrams, 1995), cat. 11, p. 82.

33. At the right of figure 15, Melzi copied a man from a Leonardo drawing in the Chatsworth Collection, which once owned the Woodner drawing as well.

34. Turner, *Inventing Leonardo,* provides an excellent overview of Leonardo's burgeoning reputation in the centuries after his death.

35. Kemp, *Leonardo on Painting,* p. 266.

36. Vasari, *Lives of the Artists,* p. 99.

37. Janice Shell and Grazioso Sironi, "Salaì and Leonardo's Legacy," *Burlington Magazine* 133 (1991), p. 104, n. 77.

38. Ibid., pp. 95–96.

39. Kemp, *Leonardo on Painting,* pp. 193–94.

40. For the condition history of *The Last Supper* through 1983, see David Alan Brown, *Leonardo's Last Supper: The Restoration* (Washington, D.C.: National Gallery of Art, 1983).

41. A major departure from the original painting is the presence of a plaque on the front of the tablecloth inscribed with the words, "AMEN DICO VOBIS QVIA VN'/ VESRVM ME TRADITVRVS E (Truly I say to you, one of you will betray me)" [Matt. 26:21]. See Leo Steinberg, "Leonardo's *Last Supper,*" *Art Quarterly* 36 (Winter 1973), pp. 297–410, for an exhaustive argument that the painting emphasizes not just the announcement of Judas's imminent betrayal but also the Institution of the Eucharist.

42. The other two are in the British Museum, London, and the Kupferstichkabinett, Berlin. See Otto Benesch, *The Drawings of Rembrandt,* vol. 2, ed. Eva Benesch (London: Phaidon Press,1973), pp. 105–6, nos. 444–45.

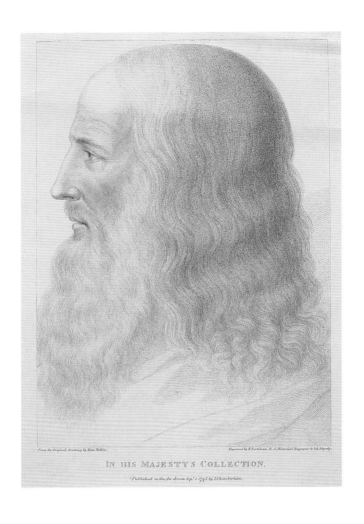

From the Original Drawing by Hans Holbein. Engraved by F. Bartolozzi, R.A. Historical Engraver to his Majesty.

IN HIS MAJESTY'S COLLECTION.

Published as the Act directs Sep.ʳ 1. 1795 by I. Chamberlaine.

1 Francesco Bartolozzi
Leonardo da Vinci, 1795
Engraving after an unattributed 16th-century red chalk drawing
cat. no. 3

The Ongoing Saga of Leonardo's Legend

THE EMERGENCE OF LEONARDO STUDIES

The greatness of Leonardo da Vinci was acknowledged by his contemporaries and has been honored ever since his death in 1519. In the first art historical survey, *Lives of the Most Eminent Painters, Sculptors and Architects* (1550, revised 1568), Giorgio Vasari portrayed him as a person whose talents were "truly marvelous and celestial." A handful of Leonardo's works of art, most notably the *Last Supper,* were reproduced in prints and books in the sixteenth and seventeenth centuries. In the late eighteenth century, during the early revolutionary phase of industrialization and democratic reform, there was a marked increase in the volume of information about Leonardo and his life, including the dawning recognition of his eminence as a natural scientist and engineer.[1] Only then did his name begin to assume the mythical proportions we know today.

Leonardo was a charismatic figure, but he offered few autobiographical comments in his voluminous writings. Three decades after Leonardo's death Vasari pointedly connected his unusual artistic and intellectual gifts to his "beauty of body" and the "infinite grace of all his actions."[2] The intensification of study and admiration that occurred around 1800 brought with it the need for a universally recognized likeness of Leonardo: since that time he has been portrayed as a long-haired, bearded seer, handsome in youth and craggy in old age. In 1795 Francesco Bartolozzi made a fine engraving of one of the most attractive portraits of Leonardo, a profile study in red chalk owned by the British royal family since the seventeenth century (fig. 1). An inscription on the Bartolozzi print indicates that the original drawing was thought to be the work of Hans Holbein, but modern scholars consider it an unattributed early copy of a lost self-portrait by Leonardo.[3]

After the French Revolution, the royal palace in Paris became the home of a national museum, now known as the Louvre, and a superb group of

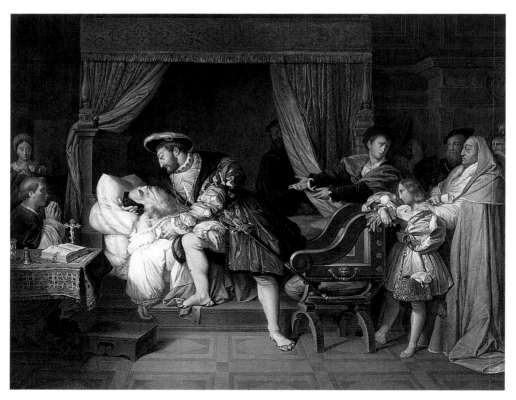

2 Théodore Richomme
Death of Leonardo da Vinci, 1827
Engraving after the 1818 painting by Jean-Auguste-Dominique Ingres
cat. no. 35

Leonardo's paintings went on public view for the first time: the *Mona Lisa,* the *Virgin of the Rocks,* the *Virgin and Child with Saint Anne,* and *Saint John the Baptist.* (Prior to this, Leonardo's only major work that was regularly and relatively easily accessible for study was the *Last Supper,* his mural decoration in the dining room of a monastery in Milan.) In the climate of international competition characteristic of the nineteenth century, France took historical and cultural pride in her patronage of Leonardo during the last two years of his life. François I appointed him painter, architect, and engineer to the royal court in 1517; a few years after Leonardo's death the king purchased the *Mona Lisa,* which the artist had probably given to Salaì, a companion of many years, who lived with him in France.[4] To bring a mythical glamour to this chapter of French Renaissance history, Jean-Auguste-Dominique Ingres painted the *Death of Leonardo da Vinci* (fig. 2). Set in a splendid bedchamber, the 1818 painting shows the master expiring in the king's embrace (this episode, described in Vasari's early biographical study, is now considered apocryphal). Ingres excelled as a painter of erudite, finely detailed impressions of historically remote epochs, but his compositions are often as fanciful as the lavishly costumed historical movies that they anticipate. Ingres's painting was publicly exhibited in Paris at the Salon of 1824 and disseminated to an international audience through a variety of copies, drawings, and prints.[5]

Leonardo studies were pursued in many specialized fields in the nineteenth century, with historians of both art and science, archivists, biographers, essayists, artists, and other professionals all examining both the man and his work. In 1810 Giuseppe Bossi, a Milanese artist, published *Leonardo da Vinci's Last Supper,* in which he detailed his project to make an accurate "reconstruction" of the master's famous mural decoration. The book inspired Goethe to write an eloquent visual analysis of the *Last Supper* and a fiery lament in response to Bossi's history of the climatic and human interventions and Leonardo's faulty technique; the combination of these factors seriously damaged the mural even before it was fifty years old. Goethe took a romantic approach to the ruined original: "May at least its remains be preserved for future times as a melancholy but worthy memorial" to an artist "endowed with clarity of apprehension and intelligence to the highest degree."[6] Bossi's version of the *Last Supper* inspired an 1819 copy in the nonfading, noncrumbling medium of mosaic. These exercises exemplify the positivistic spirit of the new attempts to keep Leonardo's legacy alive.[7]

The seven illustrations in Bossi's volume include one of the earliest engravings of Leonardo's *Vitruvian Man* (fig. 3), his unforgettable visual design demonstrating the system of human proportions proposed by the ancient

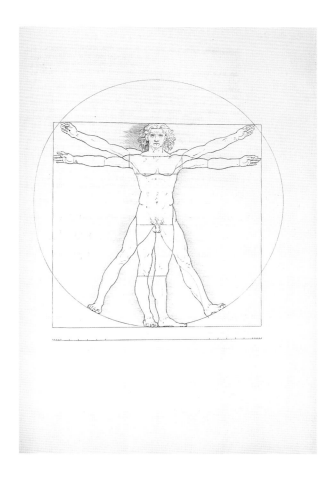

3 Giuseppe Longhi
Vitruvian Man, 1810
Engraving after the c. 1487 drawing by
Leonardo da Vinci
cat. no. 26

Roman architect Vitruvius. Measurement and the study of proportional relationships between the parts and the whole were basic to Renaissance thought, and Leonardo's *Vitruvian Man* is an enduringly popular emblem of the Platonic desire to reveal simple geometric rules connecting all things, including humans and the cosmos. In the last two centuries it has appealed to many mystical types, including, most recently, hippies and New Agers.

The *Vitruvian Man* and the *Mona Lisa* are prime examples of Leonardo's ability to invent images that seem elegantly, beguilingly, and timelessly simple. We now know, however, that they are distilled statements from an unbounded, endlessly complex visual imagination. Indeed, the incredible intricacy of Leonardo's mind was an important focus of study by various nineteenth-century specialists. Historians of science began to realize that Leonardo's unpublished manuscripts contained information about the development of many branches of science, from anatomy and astronomy to hydraulic engineering. In 1855 the French historian Jules Michelet articulated the conception of Leonardo as "the complete man, balanced, all-powerful in all things, who summarized all the past [and] anticipated the future," and, by the end of the century, international scholars moved to publish and "decipher" every piece of paper that Leonardo inscribed.[8] The fact that his manuscripts had been cropped, reassembled, and dispersed over the centuries made this mission of recuperation almost as significant as the quest for the Holy Grail. Deluxe editions of Leonardo's manuscripts, with facsimile reproductions of the drawings and annotated transcriptions of the texts, began to appear in the 1890s. For example, the anatomical drawings in the Royal Library at Windsor Castle (fig. 14) were published in several volumes starting in 1898.[9] During his lifetime Leonardo had no impact on the development of anatomical science because he did not publish his studies and he did not teach. The Victorian tomes, however, finally confirmed his stature as an independent and solitary genius in science.

LEONARDO ENTERS THE TWENTIETH CENTURY AS LEGEND AND CLICHÉ

By 1900 Leonardo, Michelangelo, and Raphael were generally considered the three greatest artists in the Western canon. Although Leonardo finished very few masterpieces, and even fewer were available for the public to visit, his legendary reputation as an easily distracted genius enhanced the aura of his pictures and turned his manuscripts into precious relics. Out of the handful of pictures, the *Mona Lisa* was becoming *the* most famous painting in the world. In the sixteenth century Vasari, who probably never saw the painting, singled it out as the perfect example of an image that is as "natural" and "alive" as the living person it depicts. In the late nineteenth century the picture's most extravagant literary admirers, Théophile Gautier and Walter Pater, focused on the enigmatic presence of the smiling woman and the

4 Robert Rauschenberg
Untitled (Captiva, Florida), 1980
cat. no. 31
© Robert Rauschenberg/Licensed by VAGA, New York, NY

uncanny way in which she mingles aloof beauty, tender charm, and a slightly sinister, Sphinx-like allure.[10] This painting now has a fame that is often independent of its creator—people who know the image of the *Mona Lisa* cannot necessarily name the artist who painted it.

The *Mona Lisa* made newspaper headlines when it was stolen from the Louvre in 1911, and again when it was returned in 1914. These sensational events solidified its status as a cult object and created a wave of Mona Lisa enterprises in all areas of popular culture: greeting cards, patterned silk fabrics, car radiator caps, songs and cabaret acts, cartoons, and advertisements for corsets, cigarette papers, and more.[11] Reference to the painting also found expression in popular music, with Cole Porter wittily equating "the smile on the *Mona Lisa*" with such fabulous things as Camembert cheese, Jimmy Durante's nose, and Mickey Mouse in his 1934 song "You're the Top." Since the 1960s the image has appeared on every imaginable piece of merchandise. A typical commercial product can be seen in a recent photograph of a folding chair casually decked with a *Mona Lisa* towel, a few items of clothing, and a newspaper (fig. 4). This seemingly mundane record of an accidental grouping is, in fact, a work of art by Robert Rauschenberg, the creator of several offbeat homages to the *Mona Lisa.*

Leonardo's *Last Supper* has been equally prone to popularization and commercial exploitation throughout this century. Christian groups have reproduced it in countless ways, and secular outfits have exploited its status as an Old Master painting. In the mid-1950s, for example, it was engulfed in the latest American hobbyist craze: Craft Master paint-by-number kits (fig. 5). The do-it-yourself version of the *Last Supper* became "the all-time

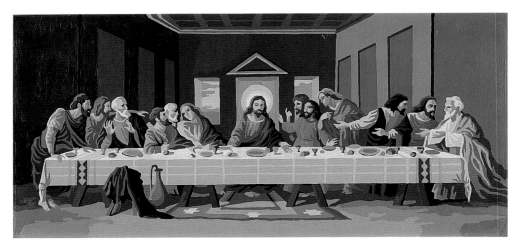

5 Unknown maker
Paint-by-numbers reproduction of Leonardo
da Vinci's *Last Supper,* c. 1960
cat. no. 43

paint-by-numbers best seller."[12] Popular culture draws on Leonardo's name and history in addition to his masterworks: his likeness inhabits many a wax museum; his name belongs to one of the Teenage Mutant Ninja Turtles in the 1980s children's television cartoon; and his biography, strongly laced with sex, violence, and magic, is now a ten-volume comic book, *Chiaroscuro: The Private Lives of Leonardo da Vinci.*[13]

Perhaps even more remarkable than Leonardo's ubiquity in popular culture is the fact of his appropriation by Sigmund Freud. Leonardo was the first historical figure to whom Freud applied the modern methods of clinical psychoanalysis. *A Childhood Memory of Leonardo da Vinci* (1910) addressed the artist's homosexuality and its relationship to his irresolution, his obsession with research, and his "double nature" as an artist and a scientific investigator. It has since been shown that Freud built his esoteric interpretation on one erroneous detail, but because the work was a landmark study, and one that Freud deemed his "favorite book," others have found it hard to ignore the topic. It is fitting, perhaps, that the founder of psychoanalysis validated the aura of sexual ambiguity surrounding the creator of the enigmatic *Mona Lisa.* Some scholars still talk of Leonardo's "supposed homosexuality," but as Roy McMullen concluded in 1975: "Although [it] cannot be proved absolutely, nearly all the signs point in one direction."[14]

LEONARDO'S ICONS VIEWED THROUGH THE LENS OF MODERN ART

Leonardo's aspiration to make art that perfectly represents and interprets "all the visible works of nature" has not been the principal goal of the most eminent modern artists. This is obvious in the case of abstract art but also true for representational works, which usually emphasize stylistic or technical mannerisms or expressive distortions. Leonardo's oeuvre continues to have a

significant impact, but artists no longer study and translate his art to their own ends (as, for example, Raphael's *Baldassare Castiglione* [Paris, Musée du Louvre] in which the sitter's pose echoes the *Mona Lisa,* or Rembrandt's study of the *Last Supper,* discussed earlier in this catalogue). The more original and provocative twentieth-century responses to Leonardo's art have come from artists who treat his historical stature as a given and refer directly to his iconic images as multivalent emblems or signs. Their blatantly undisguised quotations prompt viewers to consider why these particular Renaissance images have garnered such enduring attention and what they signify in the vast, rapidly changing visual language of this century.

Since the late nineteenth century many artists and illustrators have made capricious variations on the *Mona Lisa,* showing her, for example, smoking a pipe or wearing hair curlers. Such works are notable as examples of period wit and whimsy, but not as major artistic statements.[15] Marcel Duchamp raised the stakes of this kind of game considerably in 1919, the four-hundredth anniversary of Leonardo's death. He purchased a small colored reproduction of the *Mona Lisa,* defaced the image by penciling in a mustache and goatee, inscribed the bizarre title *L.H.O.O.Q.,* and signed it with his own name (fig. 6). The letters of the title make a coarse joke when pronounced rapidly in French: *elle a chaud au cul* (she's got a hot ass). Duchamp's iconoclasm has to be seen in the context of the new dada art movement and its antirational, antibourgeois antics. *L.H.O.O.Q.* parodied the almost sacred status of the *Mona Lisa* and exposed the clichéd look it wears

6 Marcel Duchamp
L.H.O.O.Q., 1964 version of 1919 original
cat. no. 13

after being exploited in so many gimmicky situations: it forced new life onto something important but taken for granted, and, in the process, unhinged all definitions of art and traditional notions of artistic originality.[16] Following on Freud's analysis of "repression, fixation, and sublimation" in Leonardo's mental life, Duchamp's visual reference to drag and his bawdy verbal puns invoked crude stereotypes about homosexuality. The low humor of *L.H.O.O.Q* is countered, however, by the fastidious precision with which it juggles all these ideas. Duchamp kept his creation alive with a later print called *Rasée L.H.O.O.Q.* (Shaved L.H.O.O.Q.): for this work he did not have to bother drawing in the mustache and goatee.

By asking viewers to play with and question what they see, hear, and think about the status quo, Duchamp made a definitive contribution to what is now called conceptual art. Many artists have contributed to the Duchampian tradition of visual and verbal punning: Man Ray, for example, added a fat cigar to the mouth of Leonardo's famous late self-portrait and titled the print *Father of Mona Lisa;* Howard Kottler made a set of dinner plates decorated with edited images of the *Last Supper* and titled them with reference to the excised details (*Lost Supper, Reservations for Thirteen,* and so on).

7 Robert Rauschenberg
Lisa Fugue #1, 1985
cat. no. 32
© Robert Rauschenberg/Licensed by VAGA, New York, NY

By the late 1950s Robert Rauschenberg had a reputation for combining images of artistic masterpieces and monuments with glimpses and excerpts of contemporary life, evoking a dreamlike yet real continuity between the ideals of the past and the complexities of the present. Over the last four decades he has incorporated the image of the *Mona Lisa* into various works. He often floats the portrait as one of many equal details within an all-over composition. Despite visual competition from other fragments in this unordered, open field—expressive strokes of paint, words, symbols, and/or additional images—the strong, intense personality of the Renaissance woman is never compromised. In 1959 Rauschenberg said: "Painting relates to both art and life. Neither can be made. I try to act in the gap between the two."[17] A few years later he couched his special regard for Leonardo in similar terms: "What really appeals to me . . . is his attitude—his being interested in all those things other than painting, doing those theater pieces and pageants, designing fantastic engines, when everybody kept telling him he should stick to painting." But Leonardo's paintings also intrigue Rauschenberg because every detail of every thing is "of equal importance."[18]

Lisa Fugue #1 (fig. 7) was made at a Japanese ceramic factory where Rauschenberg could experiment with photo-silkscreened decals. He arranged two *Mona Lisa* images, one upright and one inverted, like the queen in a deck of cards. The overlaying of the decals veiled the faces with shadow and emphasized the hands. The Japanese characters in the lower left are the phonetic equivalent of the word Rauschenberg; the fact that one of them is the character for mist or smoke makes a serendipitous connection to the vaporous white brushstrokes swirling at the bottom of *Lisa Fugue #1*.

Andy Warhol made his first *Mona Lisa* pictures in 1963, the year that Charles de Gaulle honored President and Mrs. Kennedy by sending Leonardo's painting to the United States for exhibition at the National Gallery and the Metropolitan Museum of Art. Warhol had recently won notoriety for identifying the Campbell's soup can as the perfect still life for the age of mass production. The *Mona Lisa*'s American tour attracted huge crowds as well as criticism from serious quarters for being a "bare-faced public-relations ploy."[19] Warhol responded quickly to both the hoopla and the *Mona Lisa*'s reputation as the world's most copied and most reproduced portrait. Demonstrating an artful counterpoint of idea and execution, he made a painting that resembles a giant enlargement of a four-color test sheet run by a commercial printer (fig. 8). Warhol printed a photo silkscreen of the *Mona Lisa* onto a white canvas again and again, in red, yellow, blue, and black; sometimes he printed one color over another or changed the orientation of the image, and he weighted his composition with a crescendo of enlarged details, printed in black. Warhol's flashing repetitions subjected Leonardo's image to the rhythmic energy of New York City and American pop art, and the *Mona Lisa* bopped along, timeless and classy as ever.[20]

8 Andy Warhol
Mona Lisa, 1963
cat. no. 45

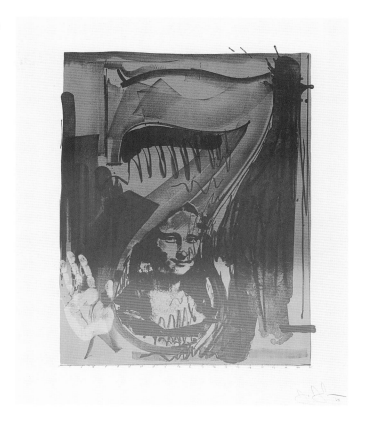

9 Jasper Johns
Figure 7, 1969
cat. no. 17
© Jasper Johns/
Licensed by VAGA,
New York, NY

Jasper Johns, like Rauschenberg and Warhol, has included the *Mona Lisa* in several works. He takes all his reproductions from a cheap iron-on transfer that he acquired in the late 1960s. Johns employs a very specific set of motifs, devices, and effects from which he has fashioned a hermetic, highly personal language. Most of his visual vocabulary deals with such fundamentals as primary colors, the discrete stroke or mark, numbers, letters of the alphabet, target and flag designs, and parts of the human body. In that context the *Mona Lisa* can stand out as an exotic while remaining a fairly common icon. In a 1969 lithograph (fig. 9) Johns combined a reversed detail of the Leonardo with a numeral, a handprint, and a few lively colors and markings. Johns has said that he admires the visual language of Cézanne and the conceptual language of Duchamp; Leonardo appeals to him because he balances the visual and the conceptual. *Figure 7* is a classic example of Johns's ability to invent a mysterious, poetically complex, and thoroughly idiosyncratic image from these interests.[21]

Robert Arneson has turned his unique humor and narrative inventiveness to two of Leonardo's icons. *George and Mona in the Baths of Coloma* (fig. 10) is a sculptural tour de force created for an exhibition on the theme of the American Bicentennial. Arneson took the portrait of George Washington engraved on the dollar bill as his symbol of the United States, and the *Mona Lisa* for his symbol of France. Even as it allegorizes America's gratitude for

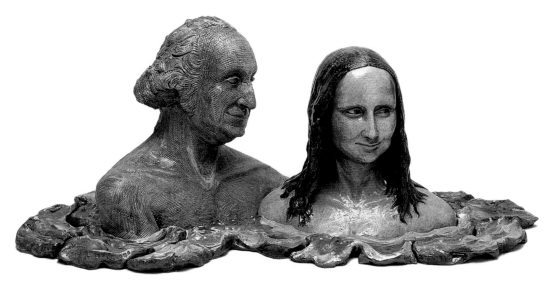

10 Robert Arneson
George and Mona in the Baths of Coloma, 1976
cat. no. 1
© Estate of Robert Arneson/Licensed by VAGA, New York, NY

France's support during the Revolutionary War, the work rebelliously undercuts the sober formality of the subject. Arneson's homage to Franco-American amity imagines a delightfully undignified get-together in a hot spring in Coloma, the little California town in the Sacramento foothills where James Marshall discovered gold in 1848. George's eyes (and, it seems, his hands) reach lovingly to Mona, whose face glows with delight. They appear happier here than in their usual incarnations. Arneson's sculpted *Mona Lisa* is an embodied sensual being and, as such, differs considerably from the nebulous photo-based *Mona Lisa* images in the works of Rauschenberg, Warhol, and Johns. Like Duchamp's *L.H.O.O.Q.,* the Arneson desecrates Leonardo's *Mona Lisa,* but it avoids Duchamp's arcane linguistic humor and wallows ironically in the American custom of popularizing and trivializing that which it seeks to honor.[22]

Arneson's loving yet corrosive parodies of Leonardo's icons continued with a series of ceramic plate variations on the *Vitruvian Man* design, all titled *A Question of Measure* (fig. 11). With a typically well-honed choice of words, Arneson's title asks viewers to question the differences between the following: Leonardo's ideal man as opposed to Arneson's short, stocky self-portrait; the elitist, highbrow aspects of courtly Renaissance life versus the funky reality of the San Francisco art scene in the 1970s; Leonardo, the noble practitioner of art's highest aspirations, and Arneson, the self-styled "ceramist, a man of baked goods."[23]

In 1972 Mary Beth Edelson made a provocative and timely use of Leonardo's *Last Supper* in a work that began as an exploration of the negative aspects of organized religion. *Some Living American Women Artists* (fig. 12) challenged every male-dominated religion that programmatically excludes

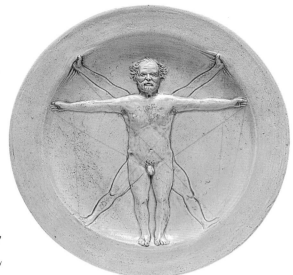

11 Robert Arneson
A Question of Measure, 1977
cat. no. 2
© Estate of Robert Arneson/Licensed by
VAGA, New York, NY

women from positions of authority. Edelson put women in the places of the thirteen figures in the *Last Supper,* then framed her sisterhood with images of many more American women artists. Reared as a Methodist, she did not intend to convey disrespect for a sacred theme; rather she used humor as the most casual and pleasing way to introduce the radical new perspective in which male hierarchies are dissolved and women have a place at the table. When published as an offset poster, *Some Living American Women Artists* found immediate rapport with the feminist movement. Although not planned as such, the poster was greeted as a feminist rejoinder to the complete absence of women artists in the standard textbook of the day, H. W. Janson's *History of Art* (first published in 1962).

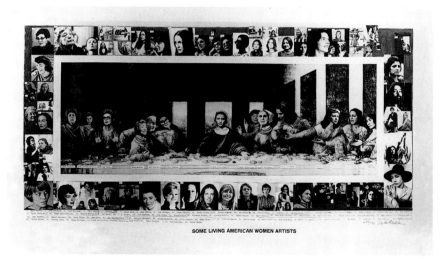

SOME LIVING AMERICAN WOMEN ARTISTS

12 Mary Beth Edelson
Some Living American Women Artists, 1972
cat. no. 15

Leonardo's *Last Supper* surely looms in the lives of all modern artists with Catholic backgrounds. Among those who adopted it in recent years, Andy Warhol, Andres Serrano, and Jerome Caja were responding in part to the spiritual malaise of the time and to the emotional pain of the AIDS crisis in particular.[24] Serrano's *Black Supper* (fig. 13) is a five-part set of photographic enlargements of a cheap sculptural ornament of the *Last Supper*. The artist painted it black, then pictured it close-up, immersed in liquid. A covering of little bubbles gave the figures a soft, scintillating spectral presence. Serrano aestheticized a modest, artless reproduction as a grand luminous icon. His image looks wondrous because its scale, setting, and light source are all ambiguous. Serrano's *Black Supper* can be cherished as a symbol of revitalized spirituality and renewed hope born of hard times. But ambiguity and duality are at the heart of this work, in which the artist expressed his contradictory feelings about his Catholic upbringing.[25]

PARALLEL SENSIBILITIES: MODERN ARTISTS WHO SHARE LEONARDO'S OBSESSIONS WITH MIND AND BODY

Leonardo's drawing of the anatomy of the arm, shoulder, and foot (fig. 14) is a prime example of scientific and artistic gifts working in unison: it presents a stately field of superbly executed images that mix the solid information of technical diagrams with the visual poetry of still lifes. These sketches share space with blocks of text cryptically penned in the left-handed artist's right-to-left writing. The sheet teems with interconnected verbal and visual information in a manner that is both magical and daunting. While this order of intensity and complexity is not unusual in twentieth-century life and art, it was unprecedented in the Renaissance. The probing, experimental sensibility of Leonardo's scientific drawings—the anatomical studies, maps, and mechanical sketches—have had an impact on modern art that is as compelling as that of his fine art masterpieces.

13 Andres Serrano
Black Supper, 1990
cat. no. 37

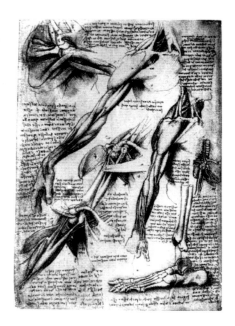

14 Leonardo da Vinci
The Anatomy of the Arm, Shoulder, and Foot,
c. 1510–11
Black chalk, pen and ink, and wash on paper
Royal Library, Windsor Castle

Seeking to make a new kind of art in the 1910s, Marcel Duchamp defied the conventions of painting handed down from the Renaissance: he explored objects that would pique intellectual and verbal interest rather than proffer immediate gratification to the eye (fig. 6). Duchamp's relationship to Leonardo was intriguingly conflicted: he spoofed Leonardo's *Mona Lisa* because it was generally idolized, but he so admired the mind behind Leonardo's scientific manuscripts and illustrations that he adopted their abstruse, technical look for other, grander projects. The masterpiece of Duchamp's early career, the *Large Glass* (fig. 15), is a distillation of notes and sketches that resemble nothing so much as fragments from Leonardo's notebooks. It is a peculiar art object in which giant sheets of glass sandwich an image executed in metallic paint, metal foil and wire. Duchamp chose the theme of sexual attraction, which he envisioned as a constant, endlessly repeating motorized

15 Marcel Duchamp
1941 celluloid reproduction
of his 1915–23 *Large Glass*
cat. no. 12

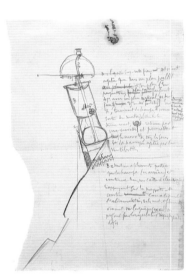

16 Marcel Duchamp
Pendu Femelle, 1913
cat. no. 10

17 Marcel Duchamp
Green Box, 1934
cat. no. 11

process. The upper section features a mechanistic virginal bride who encourages nine pluglike bachelors assembled below her; the aroused males circle above a water wheel that is connected to a chocolate grinder. Duchamp's notes describe all this in an invented language of absurdly fractured scientific phrases.

Duchamp's *Pendu Femelle* (fig. 16), a study of the mechanistic bride's "sex cylinder," juxtaposes a technical diagram with quasiscientific annotations. The inscriptions include: "This angle will express the necessary and sufficient twinkle of the eye. . . . C = artery channeling the nourishment of the filament substance, coming from the sex wasp (?) while passing by the desire regulator." Like Leonardo, Duchamp was perhaps more concerned with the formulation of his ideas than the production of finished works. And like the latterday scholars and antiquarian devotees of the Leonardo legend, Duchamp chose to dignify his own manuscripts and studies with facsimile reproductions. In 1934 he published the *Green Box* (fig. 17), a set of reproductions of studies, notes, and photographs relating to the *Large Glass* (fig. 15). He thought of these notes as his "guide book" to the piece. Leonardo never found the time to integrate or publish his scientific notes, and, as was recently observed, "the thousands of pages that do survive resemble the pieces of a grossly incomplete jigsaw puzzle."[26] Duchamp's *Green Box* emulates this confusion on a small scale. A challenging, quintessentially twentiethcentury kind of art, the *Green Box* reflects on the confusing tenor of modern intellectual life: the burden and occasional absurdity of history, the delights and horrors of the machine age, and the general instability of definitions and standards in the face of widespread, rapid change.

Joseph Beuys emerged as the central figure of postwar German art in the 1960s. Wounded and psychologically scarred by World War II, Beuys turned to quirky, metaphorically nuanced art hoping to initiate a healing process for the traumas confronting modern industrialized societies. The subjects of his delicately worked early drawings—flowers, plants, bees, swans, and stags—reflect his abiding passion for the natural sciences. A teacher, performance artist, and object maker, he saw himself as a shamanlike practitioner of the "social sculpture" that would integrate art and life, spirituality and rationalism, materialism and ecology, and Eastern and Western realms. Leonardo's intellectual curiosity, his list making and categorizing, and his creative intertwining of art and science provided an important model for Beuys. In the late 1960s he worked with students crusading for sociopolitical reform, supported feminist causes, and became one of the founders of the Green Party. Drawing on paper and blackboards became an important tool for him in his many lectures and discussions (fig. 18), and he designated many of these drawings works of art. For example, Beuys created a suite of six lithographs, *Minneapolis Fragments* (fig. 19), from the zinc plates on which he drew while delivering his "Energy Plan for Western Man"

lecture at the University of Minneapolis in 1974. (He had mounted the zinc plates together and worked on them as his "blackboard" for the lecture; he printed the plates individually three years later.) His *Minneapolis Fragments* look as hard to decipher as the pages of Leonardo's Codex Leicester, and similarly they require study. Beuys made the inscriptions to illustrate the main points of the lecture, which elucidated the distinctions between plant, animal, and human lives as well as the evolution of humanity beyond the modern age of materialism and rationalism to a "Sun State" (inspired by the early-seventeenth-century writings of Tommaso Campanella, a Dominican monk interested in natural philosophy, astrology, and utopian reform). In Beuys's vision, all forms of productivity would be understood as creative acts, energized by the democratic forces of love, warmth, and freedom. The thesis had a breadth of inquiry worthy of Leonardo, but there is no obvious

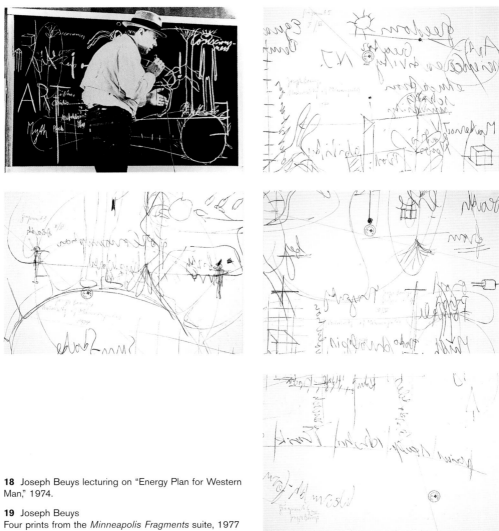

18 Joseph Beuys lecturing on "Energy Plan for Western Man," 1974.

19 Joseph Beuys
Four prints from the *Minneapolis Fragments* suite, 1977
cat. no. 5

connection between the form and style of the two artists. Beuys outlined the plans for an unknowable, yet utopian future, while Leonardo recorded empirical observations and measurements of the here and now, seeking to uncover preordained "rules." A strong connection exists, however, in the way Beuys echoed Leonardo's apparently random mixing of themes on many of his notebook pages. Both artists made complex drawings that penetrate consciousness in unusual ways, and both had a predilection for microcosm-macrocosm analogies that would connect and integrate understanding of the human body and the cosmos. In the same year as his *Minneapolis Fragments,* Beuys also began work on a large suite of drawings directly inspired by Leonardo's Madrid Codices.[27]

Mark Tansey has recently translated the breadth and interconnectedness of Leonardo's scientific thinking into an allegory. In *Leonardo's Wheel*

20 Mark Tansey
Leonardo's Wheel, 1992
cat. no. 40

(fig. 20) he echoes the Renaissance master's engineering prowess, his experiments on the movement and flow of water, and his interest in water's amazing ability to assume different states. Tansey divided his composition to contrast water subdued by engineered constructs with water in its wildest natural states. Children are placed precariously on the edges and interfaces of these worlds. Tansey invented a pictorial matrix for nature and culture, innocence and experience, and it is significant that he chose Leonardo as its symbolic center.

Leonardo's contributions to scientific inquiry remain difficult to evaluate because his extant notes are incomplete and unordered, but it is generally assumed that his interests in hydrodynamics, mechanics, mathematics, cosmology, geology, meteorology, comparative anatomy, human physiology,

and botany constitute a sprawling landmark of achievement. For many artists less eccentric than Duchamp and Beuys, Leonardo's study of human anatomy is probably the major point of contact. Pavel Tchelitchev, perhaps best known as an innovative designer for the theater in the 1930s, was a gifted draftsman with abiding passions for cosmology and the human form. In 1943 he began a series of paintings and drawings called *Interior Landscapes* (fig. 21). Critical of paintings that merely imitate nature, Tchelitchev insisted that art "has to be pure, prophetic, terrible, and sublime like the burning bush or the storm on Mount Sinai." His dramatic pictures of the interior life of the body have a dynamic and imaginative spirit akin to Leonardo's sketches, and indeed, for him, Leonardo was "the greatest man on earth of our five-hundred-year era."[28]

In the last decade Kiki Smith has made an outstanding contribution to art about the human body by combining compassion with an unflinching strength to look at all the body's functions and expressions. In a time of both plague and rapid growth in medical technology, she has maintained a steady eye on the human body as a living organism that is both delicate and resilient. In a culture glutted with idealized, glossy, retouched body fantasies, she honors humble and authentic flesh and bones. *Head* (fig. 22) exemplifies a typically fearless encounter with the interior of the body: a bronze flayed head. Not only does it have the directness of the drawings that Leonardo made from the bodies he dissected, it has something of the ghoulish power that, in Leonardo's case, may have led to charges of necromancy.[29]

21 Pavel Tchelitchev
Interior Landscape VII, 1949
cat. no. 41

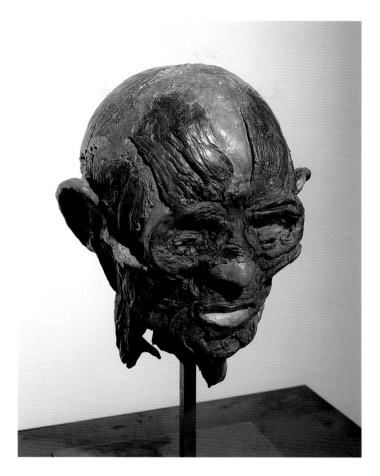

22 Kiki Smith
Head, 1992
cat. no. 39

Leonardo made unprecedented contributions to artistic and scientific knowledge, and because of this multifaceted creativity, his legacy remains strong at the end of the twentieth century. In the *Trattato della pittura,* the post-humous anthology of his writings on art, Leonardo argued that the ultimate application of all scientific inquiry is the invention and construction of art. Since the nineteenth century Western culture has been conditioned by a belief in the antagonism of art and science, and Leonardo's work has come to symbolize the former state of unity and completeness between the disciplines.

Radical twentieth-century artists have used the example of Leonardo's art in their expanding redefinitions of the form and content of art, and his name will inevitably be part of the future heritage of art and science. Paul Valéry wrote in 1894, "There remain of a man those things of which one is set dreaming by his name and by the works which make his name a mark of admiration, of hate, or of indifference. Remembering that he was a thinker, we are able to discover in his works ideas which really originate in ourselves: we can recreate his thought in the image of our own."[30] To illustrate this thesis, Valéry used the example of a man who engaged in the most complex, intense, and comprehensive perceptions: he titled his essay "Introduction to the Method of Leonardo da Vinci."

NOTES

1. In 1778 Charles Rogers produced a catalogue of the enormous collection of Leonardo drawings owned by the British royal family; engravings of seventeen examples were published in 1796 by John Chamberlain. In 1784 Carlo Giuseppe Gerli published a book of sixty-one engravings that drew attention to the diversity of Leonardo's drawings, from engineering schemes to artistic projects. In 1797 Giovanni Venturi wrote an essay on Leonardo's unpublished scientific treatises, claiming that the modern age of "the true interpretation of nature" would have dawned a century earlier if Leonardo's research had been known to his contemporaries. The history of the study of Leonardo is admirably summarized in A. Richard Turner, *Inventing Leonardo* (Berkeley: University of California Press, 1992).

2. "Besides a beauty of body never sufficiently extolled, there was an infinite grace in all his actions; and so great was his genius, and such its growth, that to whatever difficulties he turned his mind, he solved them with ease. In him was great bodily strength, joined to dexterity, with a spirit and courage ever royal and magnanimous." Giorgio Vasari, *Lives of the Most Eminent Painters, Sculptors and Architects,* vol. 4 (London: AMS Press, 1976), p. 89; this is the expanded 1568 version of the text Vasari first published in 1550 (hereafter cited as *Lives of the Artists*).

3. The original drawing is discussed in Martin Clayton, *Leonardo da Vinci: 100 Drawings from the Collection of Her Majesty the Queen* (London: The Queen's Gallery, 1996), pp. 164–65. The craggy late self-portrait (Turin, Biblioteca Reale) is also illustrated.

4. The Louvre was established in 1793 but not in full operation until 1801. The *Mona Lisa* was hung in Napoleon's bedroom before being transferred to the Louvre in 1804. Leonardo had the *Mona Lisa* with him when he moved to France in 1517, but it is not mentioned in his will. It is likely that Salai received it as a gift and took it back to Florence after Leonardo's death in 1519. The French king probably purchased the painting between 1525 and the late 1540s. See Janice Shell and Grazioso Sironi, "Salai and Leonardo's Legacy," *Burlington Magazine* 133 (1991), pp. 95–108.

5. Inscriptions on the print indicate that Goupil and Co. distributed it through their Berlin, Paris, and London galleries, and that Knoedler distributed it in New York. Ingres was not the first artist to paint the *Death of Leonardo*: François Ménageot exhibited a deathbed scene at the Paris Salon of 1784; see Turner, *Inventing Leonardo,* p. 84.

6. John Gearey, ed., *Goethe's Collected Works,* vol. 3 (Princeton, N. J.: Princeton University Press, 1986), p. 47.

7. Bossi's 1807 "reconstruction" of the *Last Supper* hung in the Castello Sforzesco, Milan, until its destruction in World War II. Giacomo Raffaelli's 1819 mosaic copy of Bossi's painting is installed in the Church of the Minorites, Vienna. See Leo Steinberg, "Leonardo's *Last Supper,*" *Art Quarterly* 36 (Winter 1973), pp. 297–410.

8. Michelet quoted in Turner, *Inventing Leonardo,* p.108. Charles Ravaisson-Mollien initiated the project to present facsimiles and unabridged transcriptions of all Leonardo's manuscripts in the late 1870s (ibid., pp. 140–41). Between 1881 and 1891 he published six volumes devoted to the Leonardo manuscripts in the library of the Institut de France, Paris.

9. The anatomical drawings and manuscripts in the Royal Library at Windsor were published in two volumes by Teodoro Sabachnikoff and Giovanni Piumati (Turin, 1898 and 1901). The steady stream of Leonardo publications in this period included a facsimile of the Codex Leicester, published by Gerolamo Calvi (Milan, 1909).

10. Gautier discussed Leonardo in several essays in the 1850s and 1860s, and argued that the *Mona Lisa* has a dark inner mood: "One senses a vague thought, infinite, *inexpressible,* like a musical idea; one is moved, troubled." Pater's 1869 essay on Leonardo (reprinted in his 1873 book, *The Renaissance*), interprets the *Mona Lisa* as a symbol of the ancient fantasy of perpetual life, a woman older than the rocks behind her, someone continually reborn like a vampire; at the same time Pater praised the picture as a preeminent example of a modern philosophical spirit which embraces complexity, ambiguity, and contingence. See Turner, *Inventing Leonardo,* pp. 110, 125.

11. The best overview of the painting's popular status is Roy McMullen, *Mona Lisa: The Picture and the Myth* (Boston: Houghton Mifflin, 1975). See also George Boas, "The *Mona Lisa* in the History of Taste," *Journal of the History of Ideas* 1 (April 1940), pp. 207–24; Molly Nesbit, "The Rat's Ass," *October* 56 (Spring 1991), pp. 6–20.

12. Karal Ann Marling, *As Seen on TV: The Visual Culture of Everyday Life in the 1950s* (Cambridge: Harvard University Press, 1994, paperback ed., 1996), p. 62.

13. The cartoon heroes are pizza-eating warrior turtles with the names Donatello, Leonardo, Michelangelo, and Raphael. *Chiaroscuro* (ten issues, 1995–96) was illustrated by Chas Truog, written by David Rawson and Pat McGreal, and published in the Vertigo line of DC Comics. In issue six the writers provided a partial bibliography of source materials, which included the most recent biography by Serge Bramly, *Léonard de Vinci* (Paris: Éditions Jean-Claude Lattès, 1988), which was published in English under the title *Leonardo: The Artist and the Man,* trans. Sian Reynolds (London and New York: Penguin Books, 1991).

14. In his recent extensive entry on Leonardo for *The Dictionary of Art* (London: Macmillan, 1996, distributed in the U.S. by Grove Dictionaries), Martin Kemp wrote: "Much has been made of his supposed homosexuality, and such evidence as is available suggests homosexual rather than heterosexual inclinations, but it is doubtful whether the notebooks and other documents provide sufficient material for a full-scale psychoanalysis in the Freudian manner" (p.196). The homosexual "signs" that McMullen considered were: Leonardo never married; there is no known heterosexual love affair; in 1476 he was anonymously accused of sodomy; for many years his household included two artist companions, Franceso Melzi and Salaì; Vasari wrote of Salaì as a very attractive youth who "delighted his master" by wearing his beautiful hair curled in ringlets; in a 1514 manuscript Leonardo mentioned an enemy who "wishes to sow the usual scandals"; women are rarely mentioned in his writings, and they are outnumbered in his drawings and notebooks by images of handsome youths and male legs, buttocks, and genitals (*Mona Lisa,* pp. 16–17). Carlo Pedretti confirms Leonardo's "uninhibited admiration for the male organ and its sexual function" in a surprisingly censorious article about a recently discovered Leonardo drawing of an angel with an erection: "The *Angel in the Flesh*," *Achademia Leonardi Vincei Journal of Leonardo Studies and Bibliography of Vinciana* 4 (1991), pp. 34–51.

15. Sapeck's early spoof, *Mona Lisa with a Pipe*, appeared as an illustration in Coquelin Cadet's book *Le Rire* (1887); see *The Spirit of Montmartre: Cabarets, Humor, and the Avant-Garde, 1875–1905*, ed. Phillip Dennis Cates and Mary Shaw (Rutgers: The State University of New Jersey, 1996), p. 105. An array of mawkish modern spoofs is illustrated in *Mona Lisas,* compiled by Mary Rose Storey, introduction by David Bourdon (New York: Harry N. Abrams, 1980).

16. Theodore Reff made a detailed summary of artistic affinities in "Duchamp and Leonardo: *L.H.O.O.Q.*-Alikes," *Art in America* 65 (January/February 1977) pp. 82–93. In 1987 Lillian F. Schwartz produced the computer-generated image *Mona/Leo,* and argued that the *Mona Lisa* is Leonardo's self-portrait; see Antoinette LaFarge, "The Bearded Lady and the Shaven Man," *Leonardo* 29 no. 5 (1996), pp. 379–83. Shell and Sironi, "Salaì and Leonardo's Legacy," p. 99, observe: "Suggestions that the Louvre picture actually depicts a man, possibly Leonardo himself, may be rejected out of hand."

17. This much-quoted statement was first published in Dorothy C. Miller, *Sixteen Americans* (New York: Museum of Modern Art, 1959), p. 58.

18. Rauschenberg quoted in Calvin Tomkins, *The Bride and the Bachelors: Five Masters of the Avant Garde* (New York: Viking Press, expanded 1968 edition of 1965 original), p. 235. In 1958 Rauschenberg discovered a process in which he laid magazine or newspaper images facedown on drawing paper moistened with lighter fluid, and then transferred the printed original by rubbing its reverse with a pencil. His *Mona Lisa* is an important early "transfer drawing" with at least eight faint reversed images of the Leonardo floating with other reversed imprints of words, numbers, and different circular motifs. Within a few years Marisol made her sculpture *Mona Lisa* (1961–62), and Tom Wesselmann incorporated a *Mona Lisa* poster in his *Great American Nude #35* (1962); see Jean Lipman and Richard Marshall, *Art About Art* (New York: E. P. Dutton and the Whitney Museum of American Art, 1978), pp. 58–60.

19. See Alfred Frankfurter's editorial essay, "A Great Lady and Her Public Relations," *ARTnews* 61 (January 1963), pp. 21, 47. Frankfurter was concerned about risks to the work of art and criticized the government and church agencies who seemed to care more about newspaper headlines than the safety of the masterpieces they sent on international tours. William Rubin made the comment about a "bare-faced public-relations ploy" in a letter to the editor, *ARTnews* 61 (February 1963), p. 6.

20. Warhol's other large painting on this theme is *Thirty Are Better Than One* (1963), a grid of *Mona Lisa* images, all printed in black on a white ground. In 1979 Warhol made more *Mona Lisa* paintings for two series based on his earlier works—the *Reversals* and the *Retrospectives*. See *Andy Warhol: Art from Art*, ed. Jörg Schellmann (Cologne and New York: Edition Schellmann, 1994).

21. For a full discussion of Johns's creative responses to the works of other artists, see Roberta Bernstein, "Seeing a Thing Can Sometimes Trigger the Mind to Make Another Thing," in Kirk Varnedoe, *Jasper Johns: A Retrospective* (New York: Museum of Modern Art and Harry N. Abrams, 1996), pp. 39–91.

The appearance of the *Mona Lisa* in the work of Johns, Rauschenberg, and Warhol may be a coded reference, conscious or unconscious, to the homosexual aura of one of the world's most famous painters. All three Americans came to critical attention in the repressive atmosphere of the 1950s. In the following passage, Theodore Rousseau is writing about the *Mona Lisa* during its showing in New York in 1963, but he could just as well be describing the somewhat closeted facades of New York's controversial new artists, Johns, Rauschenberg, and Warhol: "The picture gives the impression of a vivid, arresting person, and yet just exactly what her personality is cannot easily be defined. . . . Beneath this serenity there is a hint of strange, controlled tension. Altogether the picture is mysterious, and leaves many of its admirers uneasy" ("The Mona Lisa," *The Metropolitan Museum of Art Bulletin* 21 [February 1963], p. 223).

22. These works by Arneson are discussed by Donald Kuspit in "Robert Arneson's Sense of Self: Squirming in Procrustean Place," *American Craft* 46 (October/November 1986), pp. 36–45, 64–68.

23. Quoted from a 1978 interview with Arneson excerpted in Neal Benezra, *Robert Arneson: A Retrospective* (Des Moines: Des Moines Art Center, 1986), p. 30.

24. Warhol's *Last Supper* paintings (some of them made with photo silkscreens, others handpainted) were made in 1986 and exhibited in Milan in 1987, the year he died. San Francisco artist Jerome Caja painted in nail polish and eyeliner on small pieces of "urban debris" to create his "little lovelies." Caja's *The Last Party* (1994) gave every man in a print of Leonardo's *Last Supper* a Bozo the Clown costume. The artist was a cross-dressing performer whose funny and poignantly violent paintings embody his subversive, treasures-from-trash philosophy. See Thomas Avena and Adam Klein, *Jerome: After the Pageant* (San Francisco: Bastard Books, 1996).

25. Serrano's *Immersion* series is discussed at length in Patrick T. Murphy et al., *Andres Serrano: Works 1983–93* (Philadelphia: Institute of Contemporary Art/University of Pennsylvania, 1994).

26. Kenneth D. Keele, contribution to multiauthor entry on Leonardo in Charles Coulston Gillespie, ed., *Dictionary of Scientific Biography,* vol. 8 (New York: Charles Scribner's Sons, 1973), p. 194.

27. Beuys did the drawing project in direct response to the publication in 1974 of a facsimile edition with German translation of two of Leonardo's notebooks, the Madrid Codices. The notebooks had been found by chance in the collections of the Biblioteca Nacional, Madrid, in 1965. Beuys reproduced 106 drawings as granolithographs in his book, *Zeichnungen zu den beiden 1965 wiederentdeckten Skizzenbücher "Codices Madrid" von Leonardo da Vinci* (Stuttgart: Manus Press, 1975). The Beuys drawings are owned by the Dia Art Foundation, New York.

In his 1974 lecture "Energy Plan for the Western Man" Beuys stated "The human body is a microcosm of the world. . . . Creativity is national income. . . . The energy of the mental process gives the energy for a change in physical actions." See *Joseph Beuys in America,* compiled by Carin Kuoni (New York: Four Walls Eight Windows, 1990), pp. 8–9.

28. Quoted in Lincoln Kirstein, *Tchelitchev* (Santa Fe: Twelvetrees Press, 1994), p. 108.

29. Leonardo conducted dissections in Milan in 1507–8 and in Rome in 1514. The slanderous accusation about necromancy came in 1515 from an assistant assigned to Leonardo by Giulano de' Medici. This led Pope Leo X, Giuliano's brother, to bar Leonardo from the Roman hospital of Santo Spirito.

30. Paul Valéry, *Introduction to the Method of Leonardo da Vinci,* trans. Thomas McGreevy (London: John Rodker, 1929), p. 31. This book pairs the 1894 essay of the same name with Valéry's 1919 return to the subject, "Note and Digression." Theodore Reff notes that Duchamp knew this essay ("Duchamp and Leonardo: *L.H.O.O.Q.*-Alikes," p. 84).

This essay is dedicated to the memory of Derek Shrub, a fine and inspiring teacher.

Checklist of the Exhibition

1. Robert Arneson (American,1930–1992)
 George and Mona in the Baths of Coloma,
 1976
 Glazed ceramic
 57 × 30 × 20 in.
 Stedelijk Museum, Amsterdam

2. Robert Arneson
 A Question of Measure, 1977
 Glazed ceramic
 19 in. diam.
 Collection of Byron R. Meyer

3. Franceso Bartolozzi (Italian, 1727–1815)
 Leonardo da Vinci, 1795
 Engraving after an unattributed 16th-century
 red chalk drawing
 11 × 7¾ in.
 The Elmer Belt Library of Vinciana, University
 of California at Los Angeles

4. Joseph Beuys (German, 1921–1986)
 Leonardo "Codices Madrid," 1975
 Book, 156 pages, edition of 1000
 9 × 6½ in.
 With three examples (VI, VIII, and 3) of the
 21 granolithographs printed in an edition of
 100 in conjunction with the book
 Galerie Bernd Klüser, Munich

5. Joseph Beuys
 Minneapolis Fragments, 1977
 Suite of six lithographs
 Lithographs with ink stamp and pencil
 additions
 Each 25¼ × 35 in.
 Galerie Bernd Klüser, Munich

6. Giovanni Pietro da Birago (Italian,
 fl. c. 1471/4–1513)
 The Last Supper (after Leonardo), after
 1498
 Engraving
 8⅜ × 17⅜ in.
 C. G. Boerner, Inc., New York

7. Jerome Caja (American, 1958–1995)
 The Last Party, 1994
 7¼ × 15 × 1 in.
 Mixed media
 Collection of Eileen and Peter Norton,
 Santa Monica

8. Francesco Colombo (Italian)
 Map of Milan, 1558
 Engraving
 20⅜ × 23½ in.
 The Elmer Belt Library of Vinciana, University
 of California at Los Angeles

9. Bernardino de' Conti (Italian, c. 1470–
 after 1523)
 Portrait of Charles d'Amboise, c. 1505
 Oil on wood
 13¾ × 12½ in.
 Seattle Art Museum, gift of the Samuel H.
 Kress Foundation

10. Marcel Duchamp (French, 1887–1968)
 Pendu Femelle, 1913
 Pencil and colored pencil on paper
 12 × 8¼ in.
 Collection of Robert Shapazian, Los Angeles

11. Marcel Duchamp
 Green Box, 1934
 Mixed media
 13⅛ × 11 × 1 in. (closed box)
 Collection of Robert Shapazian, Los Angeles

12. Marcel Duchamp
 Miniature replica of *The Large Glass,* 1941
 (also known as *The Bride Stripped Bare by
 Her Bachelors, Even*), from *Boîte-en-Valise*
 Printed celluloid
 14¼ × 9⅛ in.
 Collection of Robert Shapazian, Los Angeles

13. Marcel Duchamp
 L.H.O.O.Q, 1964 version of 1919 original
 Commercial reproduction of *Mona Lisa* with
 alterations and inscriptions
 10½ × 6⅞ in.
 Collection of Robert Shapazian, Los Angeles

14. Marcel Duchamp
 Rasée L.H.O.O.Q, 1965
 Playing card mounted on folded invitation card
 with ink inscription
 8³⁄₈ × 5¹⁄₂ in.
 Collection of Robert Shapazian, Los Angeles

15. Mary Beth Edelson (American, b. 1933)
 Some Living American Women Artists, 1972
 Offset poster
 25¹⁄₈ × 38 in.
 Collection of the artist

16. Raphael du Fresne (French, d. by 1672)
 Trattato della pittura di Leonardo da Vinci, 1786
 Book, printed Bologna, reprint of 1651 Paris edition
 14³⁄₈ × 9⁷⁄₈ × 1¹⁄₄ in.
 The Elmer Belt Library of Vinciana, University of
 California at Los Angeles

17. Jasper Johns (American, b. 1930)
 Figure 7, 1969
 Lithograph
 38 × 31 in.
 Jane and David R. Davis Collection, Washington

18. Howard Kottler (American, 1930–1989)
 *Lost Supper; Out to Supper; Space Supper;
 Reservations for 13,* c. 1970
 Porcelain with decals, four examples from a
 larger set
 10³⁄₈ in. diam.
 Collection of Professors Joseph and Elaine Monsen

19. Leonardo da Vinci (Italian, 1452–1519)
 Drapery Study of Kneeling Figure Facing Left,
 c. 1470
 Gray wash and white highlighting on linen
 11³⁄₈ × 7¹⁄₈ in.
 The Barbara Piasecka Johnson Collection

20. Leonardo da Vinci
 Drapery Study of Standing Figure Facing Right,
 c. 1470
 Gray wash and white highlighting on linen
 11¹⁄₈ × 7¹⁄₈ in.
 The Barbara Piasecka Johnson Collection

21. Leonardo da Vinci
 A Horseman, c. 1480
 Metalpoint on prepared paper
 4³⁄₄ × 3¹⁄₈ in.
 Private collection

22. Leonardo da Vinci
 Grotesque Head of an Old Woman, 1489–90
 Pen and brown ink on laid paper
 2¹⁄₂ × 2 in.
 The Woodner Collection, on deposit at the National
 Gallery of Art, Washington, D.C.

23. Leonardo da Vinci
 Study of a Bear Walking, c. 1490
 Metalpoint on prepared paper
 4 × 5¹⁄₄ in.
 The Metropolitan Museum of Art, Robert Lehman
 Collection (1975.1.369)

24. Leonardo da Vinci
 Codex Leicester, c.1508–10
 18 double sheets, each approx. 11¹⁄₂ × 17¹⁄₄ in.
 Collection of Bill and Melinda Gates

25. Circle of Leonardo da Vinci
 Virgin and Child with Columbines, c. 1497–98
 Oil on panel
 19³⁄₄ × 15¹⁄₈ in.
 Denver Art Museum, gift of the Samuel H. Kress
 Foundation

26. Giuseppe Longhi (Italian, 1766–1831)
 Vitruvian Man, 1810
 Engraving, in Giuseppe Bossi, *Del cenacolo
 di Leonardo da Vinci* (Milan, 1810)
 18³⁄₈ × 12³⁄₄ in.
 The Elmer Belt Library of Vinciana, University
 of California at Los Angeles

27. Francesco Melzi (Italian, 1491/3–c.1570)
 Two Grotesque Heads (after Leonardo), c. 1510(?)
 Pen and brown ink on paper
 1³⁄₄ × 3⁷⁄₈ in.
 National Gallery of Art, Washington, D.C., gift of
 Mrs. Edward Fowles, 1980.63.1

28. Francesco Melzi
 Flora, or *"La Colombina,"* c. 1550
 Oil on panel
 29¹⁄₂ × 21¹⁄₂ in.
 Collection of Nancy S. Mueller

29. Luca Pacioli (Italian, d. c. 1514)
 *Summa de arithmetica, geometria, proportioni
 e proportionalita,* 1494
 Book, printed Venice
 13¹⁄₈ × 9 × 2³⁄₈ in.
 The Elmer Belt Library of Vinciana, University
 of California at Los Angeles

30. Ambrogio de Predis (Italian, c. 1455–c. 1508?)
 Portrait of a Youth as Saint Sebastian, c. 1494
 Oil on panel transferred to Masonite
 12¹⁄₂ × 10¹⁄₂ in.
 Cleveland Museum of Art, John L. Severence Fund,
 1986.9

31. Robert Rauschenberg (American, b. 1925)
 Untitled (Captiva, Florida), 1980
 Black-and-white silver print
 13 × 19 in.
 Collection of the artist

32. Robert Rauschenberg
 Lisa Fugue #1 (Japanese Recreational Clayworks),
 1985
 High-fired ceramic
 32¹⁄₄ × 21⁵⁄₈ in.
 Collection of the artist

33. Man Ray (American, 1890–1976)
 Father of Mona Lisa, 1968
 Offset print
 10¹⁄₈ × 6¹⁄₄ in.
 Private collection

34. Rembrandt van Rijn (Dutch, 1606–1669)
 The Last Supper (after print by Birago, cat. no. 6),
 c. 1635
 Signed "Rembrandt.f."
 Red chalk
 14³⁄₈ × 18³⁄₄ in.
 The Metropolitan Museum of Art, Robert Lehman
 Collection (1975.1.794)

35. Théodore Richomme (French, 1785–1849)
Death of Leonardo da Vinci, 1827, after the 1818
painting by Jean-Auguste-Dominique Ingres
Engraving
15½ × 19¾ in.
The Elmer Belt Library of Vinciana, University
of California at Los Angeles

36. Salaì (Gian Giacomo Caprotti di Oreno, Italian,
c. 1480–1524)
Virgin and Child with Saint Anne (after Leonardo),
c. 1520
Oil on wood panel
70 × 45 in.
University of California at Los Angeles at the
Armand Hammer Museum of Art and Cultural
Center, Los Angeles, Willitts J. Hole Art Collection

37. Andres Serrano (American, b. 1950)
Black Supper, 1990
Framed Cibachrome prints
Each 65 × 45⅛ × ¾ in.
The Baltimore Museum of Art

38. Kiki Smith (American, b. 1954)
Untitled, 1991
Paint on rice paper
36 × 4½ × 3 in.
Collection of Greg Kucera and Larry Yocom

39. Kiki Smith
Head, 1992
Bronze
17½ × 10½ × 11 in.
Collection of Shoshana and Wayne Blank

40. Mark Tansey (American, b. 1949)
Leonardo's Wheel, 1992
Graphite on paper
9 × 7½ in.
Collection of Curt Marcus, New York

41. Pavel Tchelitchev (American, born Russia,
1898–1957)
Interior Landscape VII, 1949
Crayon and watercolor on paper
12 × 8½ in.
Courtesy of DC Moore Gallery, New York

42. Chas Truog, David Rawson, and Pat McGreal
(American)
*Chiaroscuro: The Private Lives of Leonardo
da Vinci,* 1995–96
DC Comics, examples from a ten-issue series

43. Unknown maker
Paint by Numbers, c. 1960
Paint on board
18 × 35 in.
Collection of Ed Cauduro

44. Andrea del Verrocchio (Italian, 1435–1488)
Saint Donatus, c.1479
Tempera on canvas mounted on board
12 × 10¼ in.
Private collection

45. Andy Warhol (American, 1928–1987)
Mona Lisa, 1963
Silkscreen ink and synthetic polymer paint on
canvas
125¾ × 82½ in.
Private collection

46. Andy Warhol
Last Supper, 1986
Silkscreen on paper
23⅞ × 31⅝ in.
The Andy Warhol Museum, Pittsburgh; Founding
Collection, The Andy Warhol Foundation for the
Visual Arts, Inc.

47. Andy Warhol
Last Supper, 1986
Silkscreen and collage on paper
23½ × 31¾ in.
The Andy Warhol Museum, Pittsburgh; Founding
Collection, The Andy Warhol Foundation for the
Visual Arts, Inc.

48. Andy Warhol
Last Supper Detail, 1986
Synthetic polymer paint on paper
31⅝ × 23⅝ in.
The Andy Warhol Museum, Pittsburgh; Founding
Collection, The Andy Warhol Foundation for the
Visual Arts, Inc.

49. Andy Warhol
Last Supper Detail, 1986
Silkscreen and collage on paper
31⅝ × 23¾ in.
The Andy Warhol Museum, Pittsburgh; Founding
Collection, The Andy Warhol Foundation for the
Visual Arts, Inc.

50. A. L. Weise (American)
The Last Supper (after Leonardo), mid-19th century
Hand-colored lithograph on paper
22 × 28 in.
The Elmer Belt Library of Vinciana, University
of California at Los Angeles

Project manager: Zora Hutlova Foy
Editor: Suzanne Kotz
Design and production: Ed Marquand and John Hubbard with assistance by
Craig Orback and Randalee Maddox, Marquand Books, Inc.

Typeset in Monotype Poliphilus and Berthold Akzidenz Grotesk

Printed and bound by C & C Offset Printing Co., Ltd., Hong Kong

Photo credits